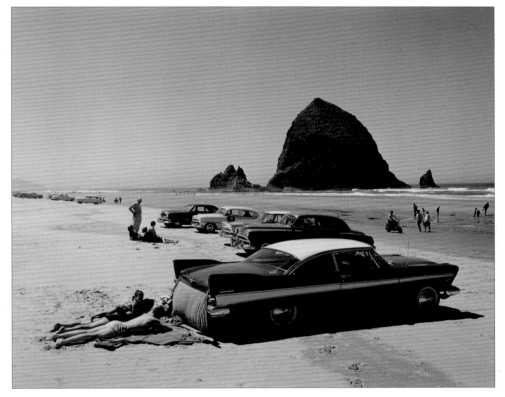

Cars on Cannon Beach. Undated. (4" x 5" negative #7615C)

OREGON,
MY OREGON

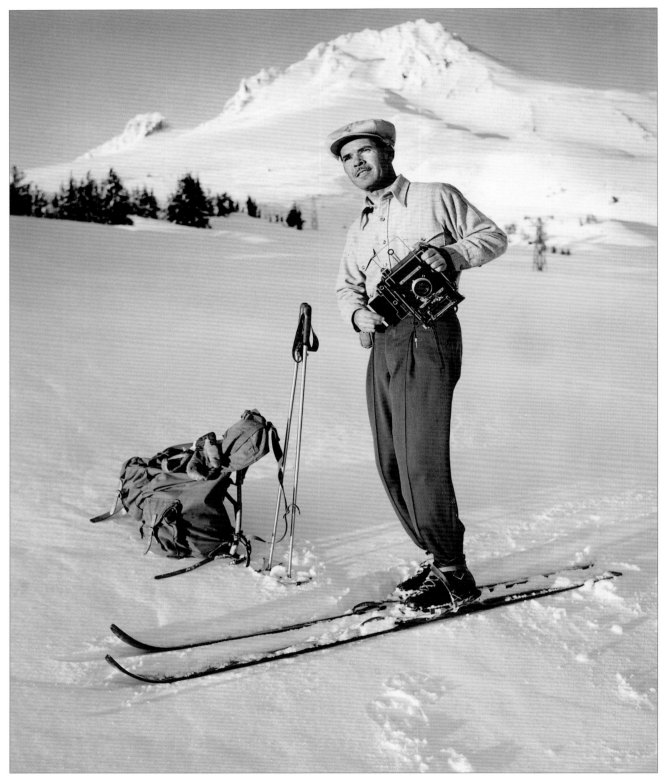

Ray and Camera. Undated. (4" x 5" negative #5571A)

OREGON, MY OREGON

RAY ATKESON

Essay by Catherine Glass

Photo Editing by Thomas Robinson

GRAPHIC ARTS CENTER PUBLISHING®
IN COOPERATION WITH THE OREGON HISTORICAL SOCIETY

Photographs front cover, pages 1, 2, 5, 6, 10, 13, 17, 22, 24-30, 32-45, 47, 51, 55, 56, 62, 64, 65, 70, 72-102, 104-111, 113-128
© MCMXCVIII by Ray Atkeson Image Archive
Photographs pages 9, 14, 18-21, 23, 31, 46, 48-50, 52-54, 57-61, 63, 66-69, 71, 103, 112, back cover
© MCMXCVIII by Photo Art Commercial Studios, Inc.
Text and compilation of photographs
© MCMXCVIII by Graphic Arts Center Publishing Company
P.O. Box 10306 • Portland, Oregon 97296-0306 • 503/226-2402

President • Charles M. Hopkins
Associate Publisher • Douglas A. Pfeiffer
Editors • Ellen Harkins Wheat, Jean Andrews, Suzan Hall
Staff Photo Editor • Diana S. Eilers
Production Manager • Richard L. Owsiany
Designer • Robert Reynolds
Book Manufacturing • Lincoln & Allen Company
Printed in the United States of America

Library of Congress Cataloging-in-Publication Data
Atkeson, Ray.
Oregon, my Oregon / text by Catherine Glass ; photography by Ray Atkeson.
p. cm.
ISBN 1-55868-321-6
1. Oregon—Pictorial works. 2. Landscape—Oregon—Pictorial works.
3. Landscape photography—Oregon I. Glass, Catherine. II. Title.
F877.A797 1998
799'.36795—dc21 98-19322
CIP

✦ ✦ ✦

ACKNOWLEDGMENTS

*Special thanks to John Patterson and Photo Art of Portland, Oregon, for permission to reproduce their
negatives that are maintained at the Oregon Historical Society. Their enthusiasm for the project
and permission is much appreciated. Also thanks go to Doris Atkeson and her son, Rick Schafer,
for information, access, and permission to use their private collection of Ray's negatives. The
cooperation and assistance of the Oregon Historical Society—especially Chet Orloff, Executive
Director; Adair Law, Publications Director; and Sue Seyl, Image Collections Director—have added
immeasurably to the final selection, historical information, and overall accuracy of the book.*

✦ ✦ ✦

Front jacket photo: *Family Outing*
Late 1920s. At Cannon Beach, Mira Atkeson peered from behind the wheel of the car while Ray
pressed the button on the family's first camera. (2.5" x 4.5" nitrate negative #S201)

Back jacket photos, clockwise: *Mary Carroll* (also on page 55); *Ray and Camera* (also on page 2);
Dodge Ad at Timberline Lodge, November 26, 1940. (4" x 5" negative #PA32295-1)

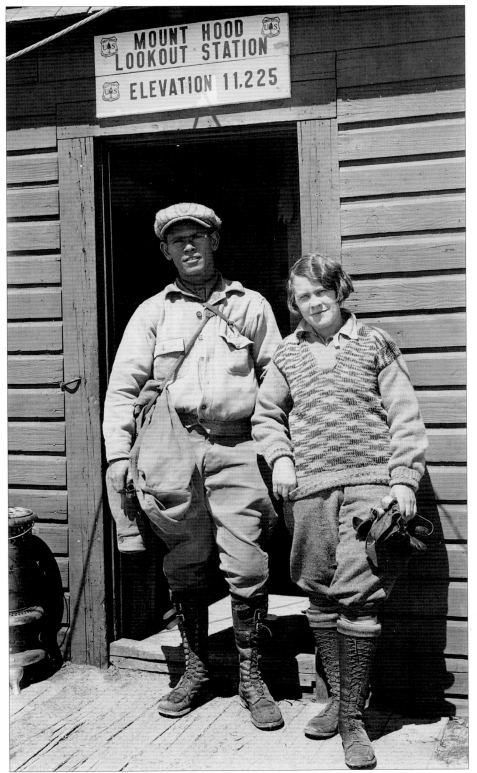

Hiking Mount Hood
Circa 1928–1930.
Ray and Mira Atkeson
at the Mount Hood
Lookout Station.
(2.5" x 4.5" nitrate
negative #S204)

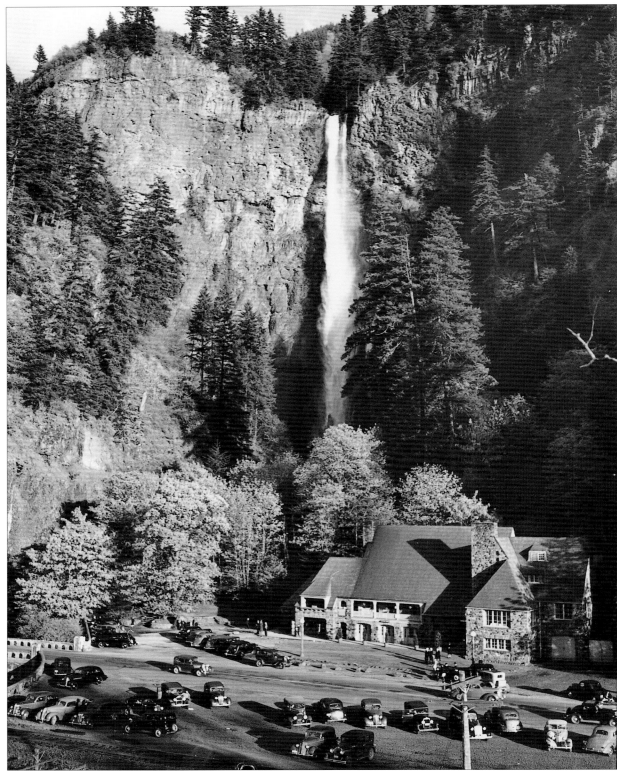

Multnomah Falls
Undated. In 1946, the Oregon State Highway Commission requested a photograph of Multnomah Falls. For fifteen years Ray had photographed the falls dozens of times, in summer and winter, in monochrome and Kodachrome, from the ground, and from the air. But often the hardest part of photography is getting paid for it. One letter from the highway commission declined his photos, explaining "We can hardly justify a $10 release price . . ." By 1948, Ray received $5 a picture out of the highway commission, and by 1962 he billed them a whopping $15 a picture.
(4" x 5" negative #2153A)

Ray Atkeson
in Black and White

by Catherine Glass

Ray Atkeson was a Kansas City boy when he left home in the 1920s to become a summer farm laborer, pitching wheat in hundred-degree heat for twelve hours a day. After two grueling seasons, Ray had packed muscle on his slender frame and, traveling in his worn-out Ford, he had seen the Rockies. That great cordillera of stone and snow made an unforgettable impression. He knew he had to return, to see more of the West.

There were few paved highways then. Driving toward the Pacific in 1926, Ray repaired and patched more than a dozen flat tires. He crossed the Mojave Desert at night, stopping at times to locate the road, which had disappeared under drifting sand. Wandering through California, almost penniless, he was happy to land a job in Mount Shasta, but when the box factory burned down, he headed north. Picking apples in Hood River and staying in a shack on a hillside above Odell, Ray saw Mount Hood and Mount Adams and knew he had found the country he would call home. By then he had found his vocation, too.

Working as a night janitor as a teenager, Ray had set his box camera on a window ledge one snowy evening, opened the shutter, and gone on cleaning. A long time passed before he remembered the camera and ran back to close the shutter. To his surprise, the slow speed of the black-and-white film had created a photograph stunning enough to win prizes and to be printed in the *Illustrated London News.* That was sheer luck, and Ray knew it. What would carry him through the years ahead would be his indomitable spirit.

Having decided that he would settle in Portland, Ray found steady work in 1929 operating a freight elevator for Montgomery Ward, but he could not

ignore the call of his camera. When he heard that the owner of a photo studio needed temporary help, he swapped job security for the irresistible opportunity to run errands, wash and dry prints, set up lights, and fire the powder flash.

Within a year he began to create the remarkable black-and-white photographs that would document Oregon over four decades, from the 1920s to the 1960s. A selection of these images, most of them never published in book form before, have now been collected here. Ray Atkeson's *Oregon, My Oregon* includes an astonishing range of photos: some are historically significant; others, uncannily timeless. With their haircuts and aviator glasses, the boys that Ray photographed drinking mountain-cold beer and eating pretzels at Cloud Cap could be certain young men of today. Only their foot gear and the date on the negative (1933–34) tell us these kids were young more than sixty years ago (page 38). This and other of Ray Atkeson's photos possess what Susan Seyl, image collections director of the two-million-plus images at the Oregon Historical Society, calls "an intriguing immediacy." She points as well to "the strong composition of Atkeson's views, the playfulness of many of his commercial photographs, the power of his Oregon icons."

It was during the Depression when Ray began working six days a week at Photo Art Studio, learning the demanding complexities of industrial, advertising, still life, and portrait photography from Claude Palmer, his perfectionist employer. On Sundays, Ray headed out to explore Oregon and to take photographs. By then he had fallen in love and, undaunted by his low wages, married Mira Crane, his match in calm optimism. In one of Ray's first photos (front cover), snapped at Cannon Beach with a Brownie, Mira's game smile gives no hint

that they had just traversed 120 sickening curves down to the water (this was the before the Coast Highway was built) and their car was on its last legs. Hiking, climbing, and skiing with him, Mira lost her smiling cool only once, when she thought Ray had been crushed under several tons of ice.

Ray Atkeson was an Oregon explorer. Before him came the Indians, who had arrived ten thousand years and three hundred generations earlier. During the eighteenth century, the English Captains Cook and Vancouver and the Spaniards Perez, Bodega y Quadra, and Hezeta, cruised the coast in preposterously small, surprisingly seaworthy ships, and the Rhode Islander Captain Robert Gray sailed up the great "River of the West" and named it Columbia. Meriwether Lewis and William Clark and their Corps of Discovery blazed the overland route, reaching Oregon in 1805, and were in turn followed by fur trappers and traders, who brought whiskey, diseases, and an unquenchable thirst for profits. In the 1820s, the intrepid and tireless British botanist David Douglas, who gave his name to the Douglas fir, traveled thousands of Oregon miles.

The first wagon trains rolled in soon after, bringing settlers and missionaries. Feverish prospectors poured in with the discovery of gold in Oregon's eastern and southwestern reaches, while descriptions of Oregon, published in newspapers around the nation, brought defeated Confederate soldiers, German farmers, Finns who fished, and Basques who herded sheep in the southeast. Asians came to build railroads. African-Americans came to build ships. East of the Cascades, cowboys rode into unmapped terrain—with only their horses and saddle blankets, their rifles, and the clothes on their backs—and created great cattle ranches, spreads larger than some eastern states.

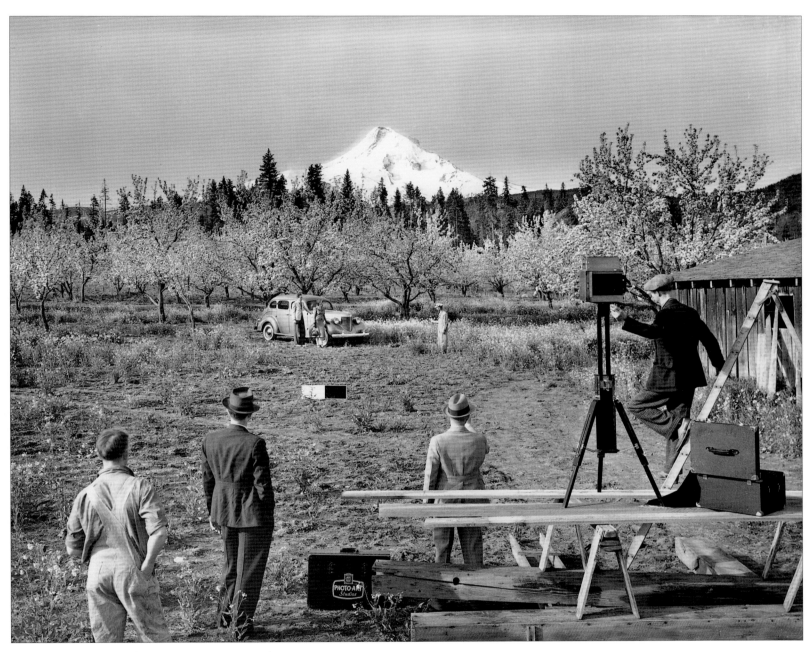

Hood River Farm Country

May 10, 1938. Ray photographed the Photo Art crew on a color advertising assignment in Hood River. Professional models portrayed vacationing motorists with a brand new Chrysler. The special camera shown here exposed three black-and-white negatives simultaneously. Through a complex process, the three images were dyed and rejoined to create a color print. A few months after this photo shoot, Kodak introduced Kodachrome color sheet film, and this state-of-the-art camera became obsolete. (8" x 10" negative #PA19821-A)

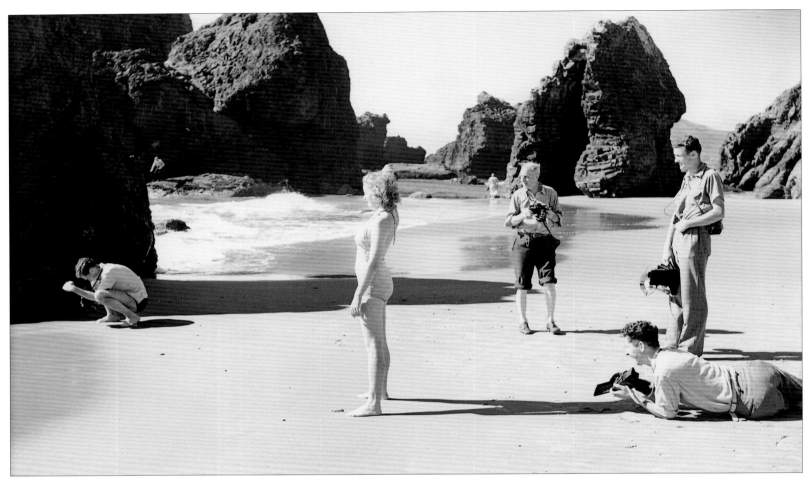

Camera Clubbers at the Beach

August 1939. The occasion was the annual beach trip of the Oregon Camera Club. Aspiring models posed in exchange for free prints from the photographers. *Oregon Journal* photographer Al Monner accompanied them on this trip, rewarding them with a full-page photo essay in the Sunday edition. Monner reported that the camera clubbers made 619 exposures that day. Hal Lidell (lying prone) was photographing model Dorothy Wheeler's silhouette. Ray, working as a professional photographer six days a week, explained why he spent the seventh photographing with hobbyists: "When I go stale, I get involved with my friends who are amateur camera fans. Their enthusiasm never fails to rejuvenate me." (6 x 9 cm negative #2833C-5)

They all left their stamp on Oregon, and Ray, who would later become world famous for his color photographs, took Oregon's measure in black and white—in black and whites so alive with detail, you feel you can touch them with your eyes. Look at the photo shot in the Wallowas in 1945 on Timberline Ridge (page 91). Ray gives us the black twisting trunk of the tree, the soft glow of the cowboys' leather chaps, the rough nap of granite, and the cold density of snow. His depth of focus goes on for miles, past the checked shirts of the cowboys who have just walked their horses over the sun-warmed ridge, past the needles of the pines behind them, past the snow frozen in the gullies of the mountain beyond the pines, past even the scarred stone of the mountain's summit to the clouds dissolving in the sky.

Photo Art Studio, one of three major photography studios in Portland, was best known for being able to deliver a first-class print the same day. Call Photo Art in the morning with an order for an aerial of your factory or a new ad, and the developed prints would be waiting for you at five. Ray Atkeson was one of the photographers who went up in a little plane or scrambled into the stinking hull of a ship or stepped onto a ball field to bring back the shot. Short notice, expert results made the studio famous. Photo historian and fine arts photography printer Tom Robinson says, "Ray went into Photo Art a real straight shooter, then developed his lighting skills and turned into a technically great photographer who could always be counted on to produce the photographs people wanted."

Ray loved to shoot outdoors, and in his day many Oregonians worked outside. The people who came to Oregon were a self-reliant bunch who knew they could fish (for trout, tuna, salmon, bass, sturgeon, bluegill, catfish, perch, halibut, crab, clams, oysters) or hunt (for deer, elk, ruffed and sooty grouse, pheasant, canvasback, and wood duck) if the going got rough, as it often did. In the land they called Eden, Oregonians grew wheat and fruit, potatoes and onions and hops; raised cattle and dairy cows; made cheese; and cut down Douglas fir, cedar, and hemlock. Of Oregon's nearly 62 million acres, 20 million were in farms cultivating crops and raising livestock, and 28 million acres were in forest, largely controlled by the federal government, which still owns one-quarter of the state. At the time, there were just a million people, so there was plenty of space—approximately sixty-two acres for every man, woman, and child.

In Ray Atkeson's photos, the life lived on the land is both intricate and simple, risky and repetitive, physically demanding and emotionally dramatic. Ray's respect for those who made their living with their hands—their endurance and the intensity of their attention—is always evident. His technical mastery of his craft allowed him to record these Oregonians, to evoke the source and context of an action with composition, texture, and line. He shows us the solitary figure of the boom man, leaning the whole force of his strength into building the raft of logs he will float to the mill (page 26). He lets us taste the dust in the throats of the cowboys driving cattle (page 90). He catches the quiet elation of the fishermen who have caught a big salmon (page 96). In his photograph of a man mending nets, he strongly reminds us of the old phrase, *laborare est orare,* "to work is to pray" (page 78).

Ray Atkeson bears witness with equal attentiveness and expertise to life in the city and the port that

shipped the grain and cattle and fruit and wood and made life on the land possible. His images are as varied as the curious, indifferent, hostile, and beguilingly friendly faces in his group portrait of shipyard workers at the changing of a shift (page 57). With superb lighting and focus, he captures the stillness of a child in an ophthalmologist's chair (page 19), the blackly illuminated Zoma carnival stall surrounded by patrons at night (page 112), and two Portland Police stalwarts in the Crime Lab (page 21).

Among the portraits he shot is one of Dorothy "No Sin" Lee (page 45). Lee ran for mayor of Portland in the 1940s on the promise to end vice and criminal violence. She cleaned up the Police Bureau and shut down the slot machines and gambling joints. Slender, her suit jacket unbuttoned at the throat, the mayor sits in her office, American flag and a fan behind her, piles of paper on her desk, and looks at us with a firm, slightly provocative gaze that seems to say: *Interest me. Tell me the truth.* In this photo, Ray Atkeson shows us the integrity, determination, and intelligence that made Lee an irresistible force. In 1949 a recall effort was mounted against her, and she was derided in the press for being a woman and wearing a hat. It was, however, hard to deny her success in curtailing corruption, and the recall effort failed.

In a striking shot of Duke Ellington, composer, pianist, and jazz orchestra leader, Ray's cross lighting reveals the Duke's imperturbable persona and the coiled excitement of his high school fans (page 67). The Duke—who played Portland during the early 1940s, a time when his orchestra was recording "Ko-Ko," "Bojangles," and "Blue Serge"—was signing autographs at J. K. Gill. "That was one of the great

bookstores of its time in the country," declares writer and historian Terence O'Donnell, who notes that Portland has always been "a city of readers." Some years, Multnomah County Library (page 44) boasted the highest circulation of books per capita of any American town. The Gills, a local family who loved music and books, built a Poet's Corner in their store, complete with paneled wood walls and a fireplace.

The disappearance of the Poet's Corner and the Music Department—indeed, the store itself—underscores the significance of Ray's photographs as a historical record. He catches vaudeville's dancers, singers, and magicians before they vanished in a cloud of feathers for all time from local and national stages (pages 58 and 59). He records the festive arches on Southwest Third Avenue before they were torn down (page 14), and he captures horse-seining for salmon before the horses and men wading thigh-deep in the Columbia were gone forever (page 86).

The salty water that rejuvenated the old horses had been so thick with salmon Native Americans said you could "walk on the backs of the fish." That changed in the 1930s when the federal government began building a series of massive dams on the Columbia. Exploiting the heavy rains that also support Oregon's great forests and the snowmelt that fills rivers and streams, the dams diverted water for irrigation, power, and flood control. Ray photographed construction of the Bonneville Dam in the 1930s (page 105) and the dynamite blasting for The Dalles Dam in the early 1950s (page 83). The backwater from The Dalles Dam inundated the Indians' sacred fishing grounds at Celilo Falls. Ray Atkeson shot Celilo before the roaring falls were silenced and the flashing salmon torpedoing upriver became ghostly legends (page 81).

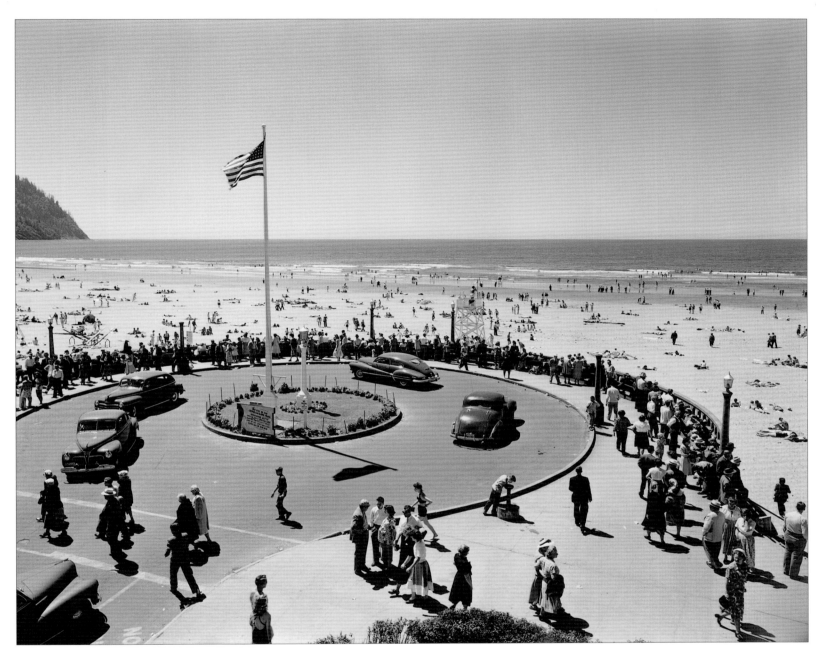

Seaside Turnaround

Circa 1948. The Seaside Turnaround sign proclaims that it is the "End of the Oregon Trail." The resort is better known among students as a place to forget history lessons. In the late 1940s, Seaside became a hot spot for motorists determined to avenge wartime rationing. Spring break and summer vacations filled Seaside with shiny chrome cars on a travel and leisure binge. Tourism advertising was the main market for Ray's stock photography business. However, the photographs that Ray really wanted to take could only be made when all the people he was hired to attract went away. Then he could photograph his vision of the Oregon coast in a solitude that can only be shared with the wind and the waves. (4" x 5" negative #5778B)

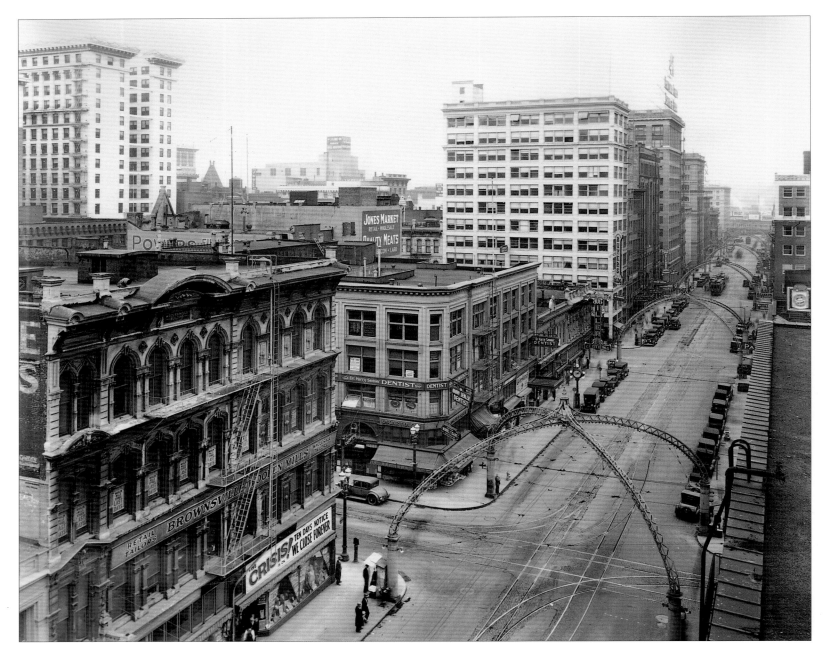

Buyer's Building

Circa early 1930s. A realtor who was selling the building one block down on the left commissioned this photograph, which shows Portland's Third Avenue at Morrison, looking north from the rooftop of the Mohawk building. Third Avenue was a proud street when the decorative lighting arches were installed in 1914. The ornamental arches originally extended along Third Avenue from Northwest Glisan to Southwest Yamhill. Beginning in the early 1920s, the arches were gradually removed due to construction and street widening projects. Those shown here were the last ones to go, eliminated at the request of the merchants in 1934. (8" x 10" nitrate negative #PA3350A)

14

These were the decades when recreation was seizing the nation's imagination. Ray was photographing for Jantzen and White Stag, Oregon sportswear outfitters (back jacket, lower left), and for the new resorts, like Timberline, that capitalized on Americans' ability and willingness to travel because cars were safer and faster and roads had improved. Oregonians were heading to the beach, the high desert, and the mountains, in part because Ray had shown them they could.

Oregon was the first state to use a gasoline sales tax to support highways, the first state to allow its citizens free access to the beach. Underlying these changes in legislation in the early twentieth century was a profound psychological metamorphosis. The early pioneers had avoided forests and mountains, traveling through them only when they had no other recourse. In their diaries they described snowy peaks as ghastly, and they felt no attraction for the beach. But as life and travel became easier and as they acquired more leisure time, Oregonians took to wild places as a way to recapture their own wild souls. Ray Atkeson's photos record their pleasure in this liberation and the beauty and freedom that he found in the wilderness.

The photographs Ray took often suggest that the only one to have witnessed the scene before he did was God. To get his pictures, he drove hundreds of icy miles on unimproved roads, packed his photo gear on his back, and hiked mountains in the days before ski lifts, climbing weary hours through snow that was sometimes knee-deep. He was not a great skier. He was often, in his own words, involved in "eggbeaters," terrific tumbles that left him bruised or even broken, but he continued to take chances because he believed taking chances brought him the best pictures.

Back in the 1930s, there were no accommodations at Mount Hood except a dilapidated old cabin buried under twenty feet of snow in winter. Enjoying its doubtful comfort meant a three-and-one-half-mile climb through the forest on a Saturday night, after work, usually followed by an hour or so of digging to reach the entry door, prudently located up near the roof. "Sometimes," Ray said, "when the weather was sufficiently bad to have discouraged less energetic outdoor enthusiasts, our little group might enjoy the luxury of sagging bed springs. . . . At other times, we would huddle, with too many other hardy souls, on benches which had been nailed to the wall."

To capture his ski photos of the 1930s and 1940s, Ray positioned himself on a particular slope inside or outside the skier's turn, pulled off his mittens and adjusted his lens, aimed his camera, fired two synchronized flashbulbs to throw light on the figure speeding toward him, and then—having grabbed his shot—threw his body between the camera and the flying snow to shield his lens. Sometimes he used a tripod, fitted with ski-pole rings to keep the legs from sinking into the snow. All the time, he had to protect the camera from moisture and cold. When he was back in the lab, processing the film, he called on his technical expertise to urge the negative into revealing the photo he hoped was there.

Hunting for photographs the way another man might hunt for deer, Ray had to rely on all his skill, ingenuity, and patience. Creating photographs, he had to draw on all of his artistry. Luck, he noted, didn't play a major role: "Consistent production of those 'lucky' photographic breaks actually represents hundreds of frustrating hours, hundreds of failures of one sort or another, repeat trips too numerous to mention to catch

those 'lucky' conditions, diligent study of the subjects to determine what situation should produce the most striking lighting conditions, pre-dawn trips by car or trail, postponed meals and sleep, unending worry about the many things that can and do happen to destroy the picture after it has been taken."

The upshot of Ray's exploration into Oregon was that increasingly he didn't want to shoot on assignment. He didn't feel "temperamentally equipped" for it. He wanted the life of a freelance photographer. In 1946, in another of his leaps of faith, he left Photo Art to strike out on his own. By the 1960s, he was shooting almost entirely in color. Once again, his dedication to his craft was rewarded. The enthusiastic mobility of Americans after World War II was like a great wave, lifting Ray's photographs and Oregon into the major national magazines and into a series of best-selling books, including *Oregon, Oregon II,* and *Oregon III.*

Meanwhile, the thousands of black-and-white photos shot by Ray Atkeson for his own portfolio and for Photo Art lay, for the most part, unseen and unremembered. They retained their secrets until Graphic Arts Center Publishing®, the Oregon Historical Society, and the Atkeson family decided they must be published.

Tom Robinson researched the photos included in *Oregon, My Oregon* by reviewing the hundreds of thousands of Photo Art Studio negatives housed in the collections of the Oregon Historical Society and the more than ten thousand negatives in the Atkeson family collection. Examining each negative on a light table with a television camera set up to reverse the image from a negative to a positive on the monitor, Tom selected four hundred. Then he took the negatives to his darkroom and printed them. His circa 1940s enlarger, which he describes as "a behemoth Saltzman that weighs almost as much as a small car," is generally regarded as the finest large-format enlarger. He had it fitted with new Nikkor lenses and a multicontrast light head.

His mission was demanding and complex: modern printing techniques do not apply to old negatives, the old negatives do not fit modern paper, their very sensitive emulsions are often on the crumbling edge of disintegration, and they require darkroom gymnastics to address their density ranges. Nevertheless, Tom Robinson met these and other challenges, in addition to researching and writing the captions.

Susan Seyl of the Oregon Historical Society speaks of "the anticipation that Ray Atkeson's photographs excite." That anticipation was part of Ray's life, as well. He wanted to get up in the morning and get to work photographing. He was forever looking for a certain play of direct and reflected light, for a landscape that spoke to him, for a face or a gesture that held him. Back at the studio, he experienced the suspense that is always part of the darkroom.

Shooting photographs before there was color film, Ray lugged his cameras, tripod, and film packs into the Oregon wilderness to bring back visual images. During those same decades, using studio cameras, he photographed a startling range of commercial subjects in black and white. The result, says Tom Robinson, "is one of the most important bodies of photographic work in the state," inviting us to revisit the country of remembrance: Oregon when we were young. Oregon before some of us were born.

For sixty years, Ray Atkeson made pictures that stay with us. To our great good fortune, a selection of those images is presented in *Oregon, My Oregon.*

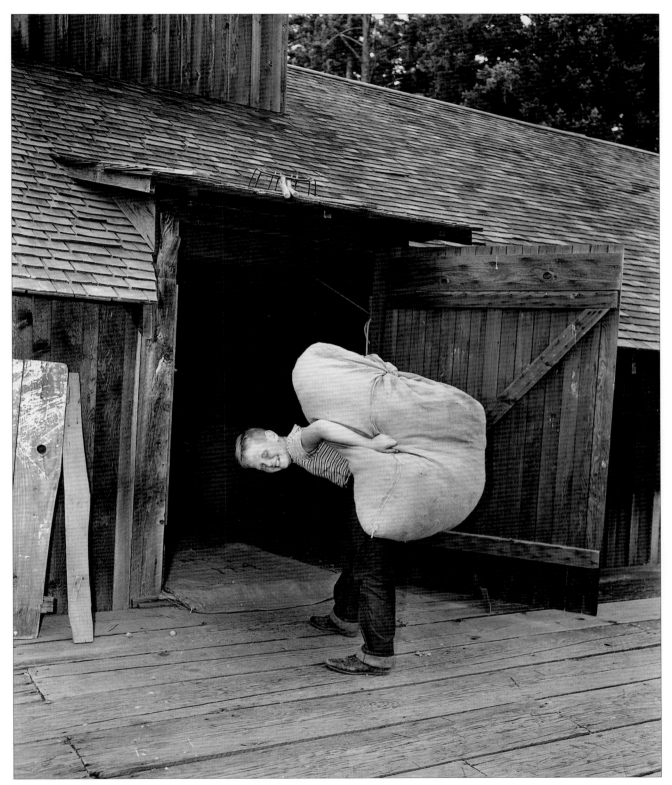

Farm Photo
Circa 1947–1948.
A farm boy carried
a huge bag of hops
to the barn. The
temperate climate
makes Marion
County a prime hops-
growing region.
(4" x 5" negative #5366B)

17

Guardian Loan Models

Circa February 1931. After the many bank failures at the height of the Depression, savings and loan associations had to advertise for depositors. The Ham Jackson Agency often called on Ray to provide photographs. Guardian offered prospective depositors 10.6% on "thrift debentures" at their "institution" (not a bank) located in Portland on Southwest Salmon at the base of the Park blocks. The child's bank, a cast of the aviator Lindbergh, probably was a wiser repository for deposits; Guardian was out of business within a year. (8" x 10" nitrate negative #PA4063)

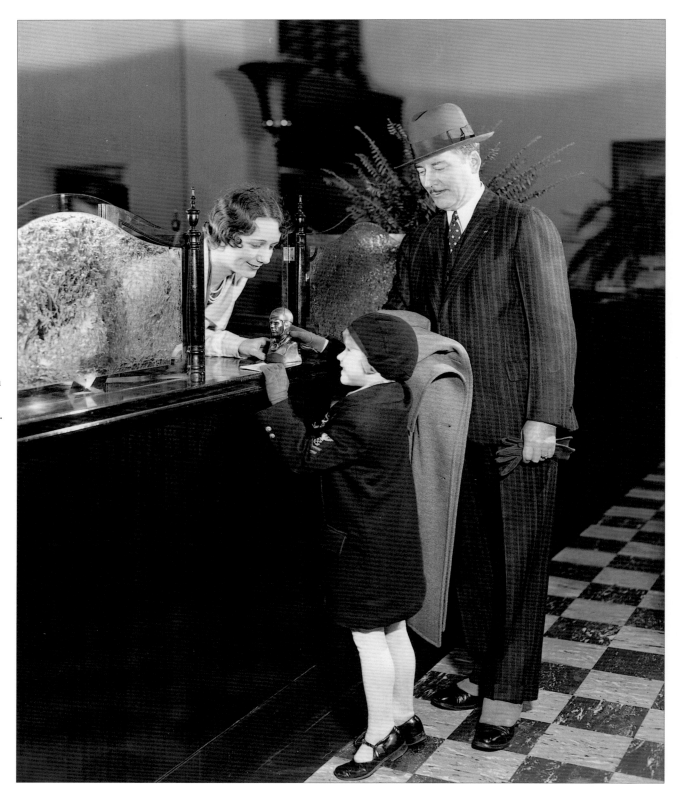

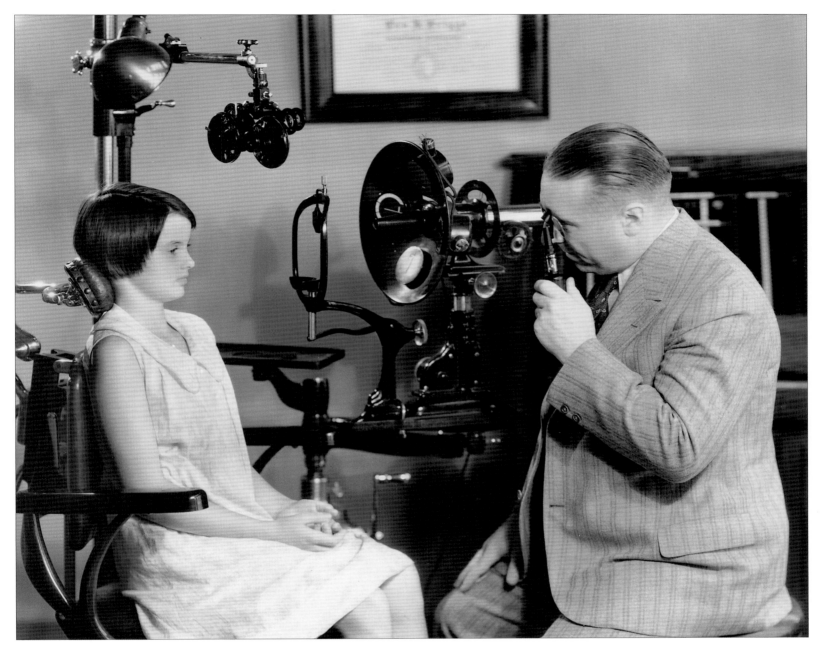

Columbian Optical Company

Undated. Here, Ray showed off the latest optical equipment in a very engaging manner. Columbian Optical was founded by the Noles family in 1905. After starting in a small, ground-floor location, by 1940 the company had grown to become one of only five firms in the United States that could produce glass eyes. The certificate hanging in the background is made out to Ben Griggs, the company vice president.

(8" x 10" nitrate negative #PA6438)

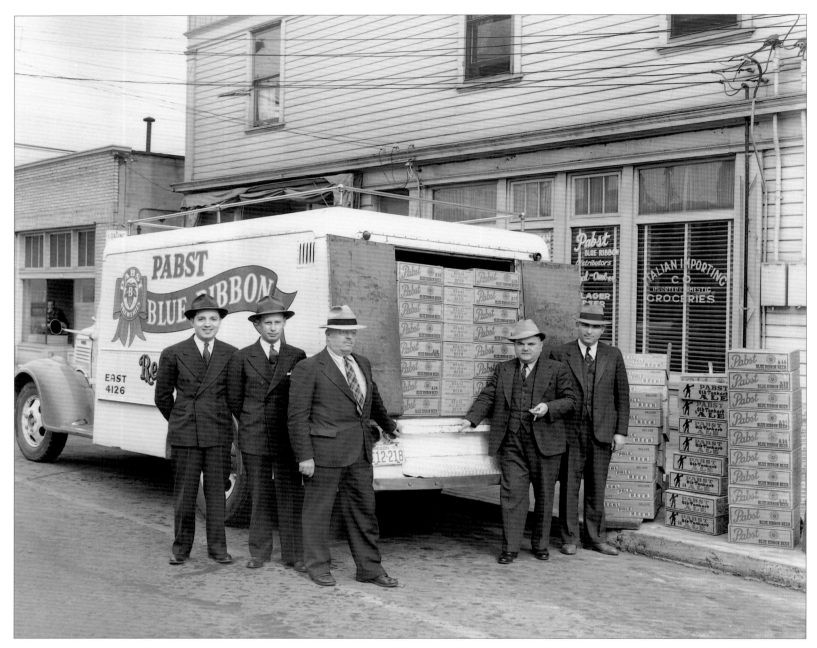

Pabst Blue Ribbon Beer
April 17, 1940. Flanked by salesmen, a Pabst Blue
Ribbon beer truck was parked in front of Mr. Bocci's
New Italian Importing Company at 1537 Southeast
Grand Avenue in Portland. Ray considered this photo a
good example of his commercial work and requested
extra prints for samples. (8" x 10" negative #PA29545)

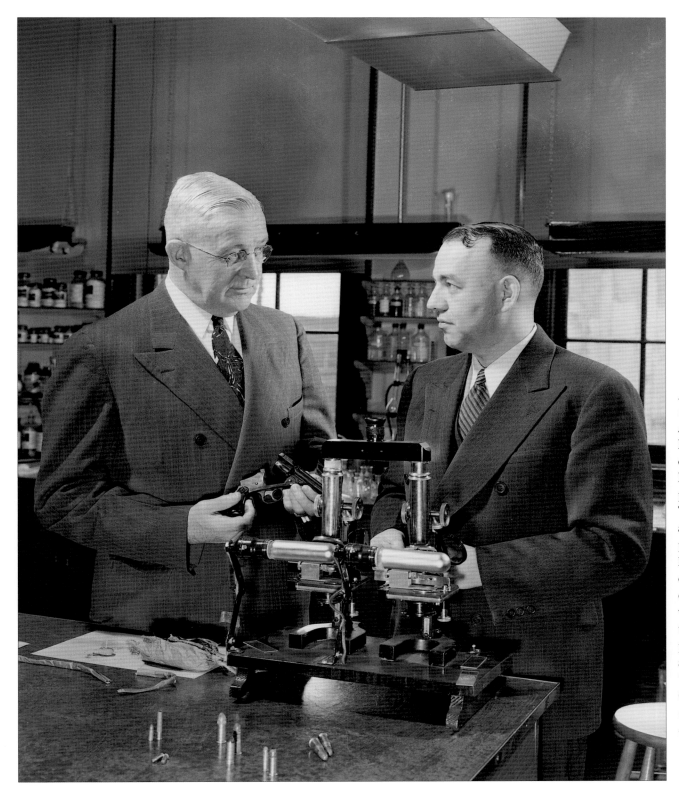

Police Department Crime Lab
April 24, 1944. Ballistics tests were conducted with a Bausch & Lomb comparative microscope. The crime lab shared a room with the police photography lab. The police lab, equipped with better cameras than Ray was using, had been the subject of a photography magazine article entitled "Shooting for the Coroner."
(8" x 10" negative #A61209-2)

21

Oregon Cascades Timber
Circa early 1940s. Ray identified these trees in the Mount Hood National Forest as hemlock and Douglas fir.
(4" x 5" negative #3807B)

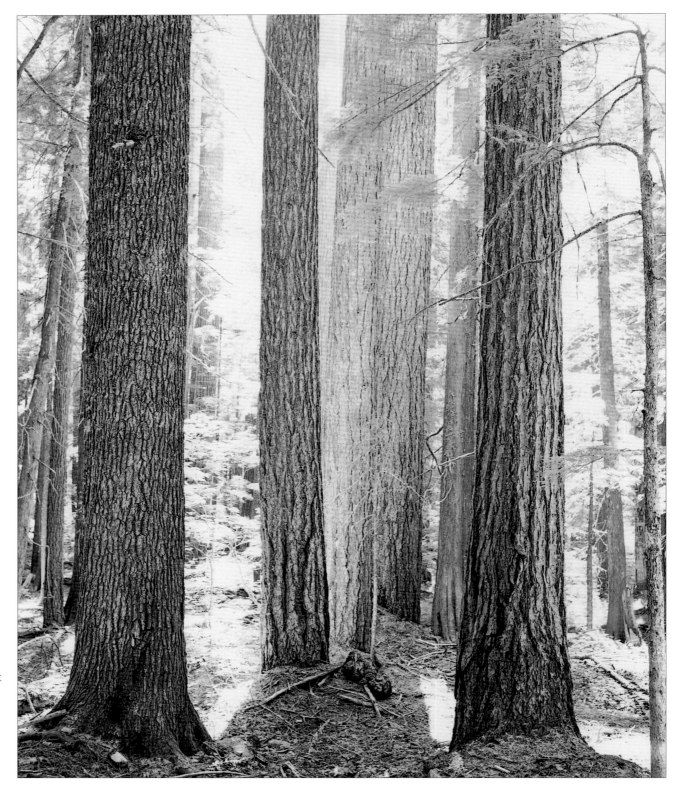

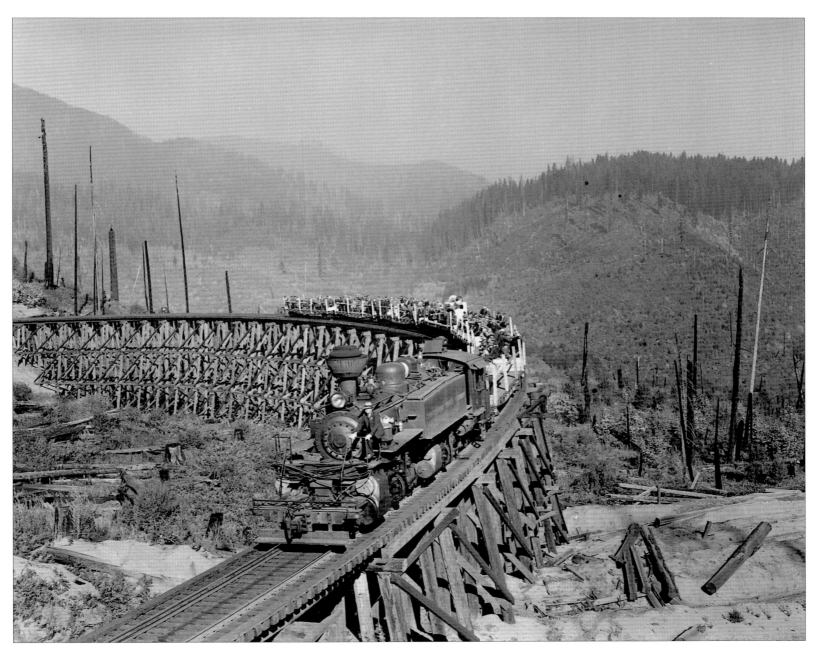

Train on Logging Congress Trip
October 13, 1939. The 1939 Pacific Logging Congress took an excursion through what was left of the Tillamook forest after the Tillamook Burn of 1933. Although Ray would not have found that the burned-over forest fit his definition of beauty, he managed to make, as he would say, "an attractive picture out of practically nothing." (4" x 5" negative #PA27168-2)

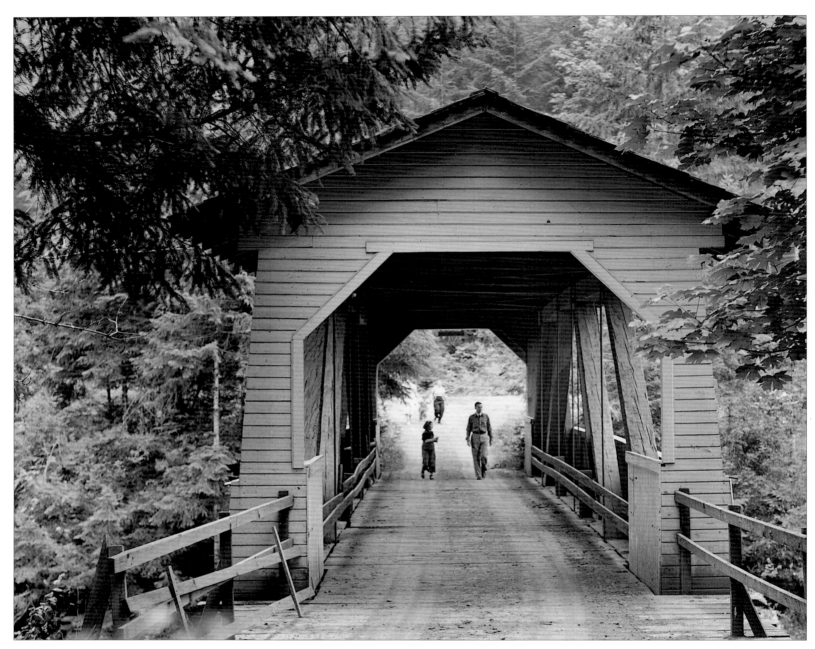

Covered Bridge
1937. A covered bridge
gave access to vehicle
and foot traffic alike
across the Santiam River.
(4" x 5" negative #1747A)

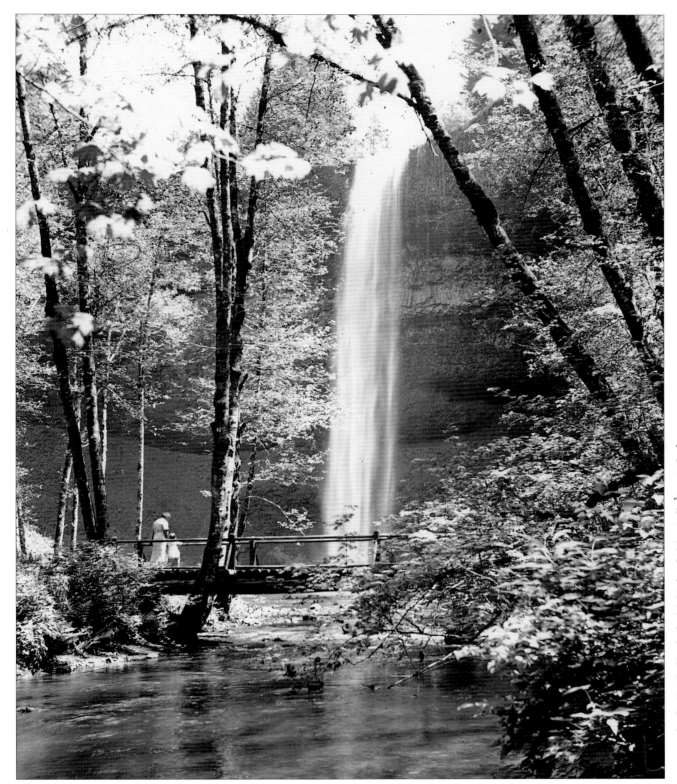

South Silver Creek Falls
1937. The *Oregon Journal's* rotogravure section of June 18, 1939, published this photo with the caption, "Eleanor Jean Atkeson [Ray and Mira's daughter] and Lucile Devine on one of the rustic bridges which cross South Silver Creek below the main South Falls near Silverton." (9 x 12 cm negative #1701B)

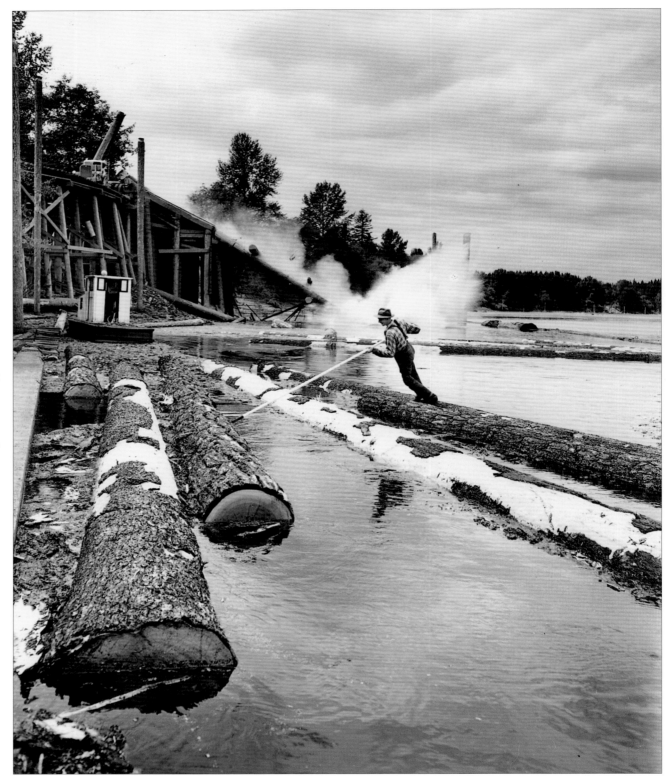

Log Dump in Oregon

Circa early 1940s. Here, Ray framed the logger with the spray of the log dump in the background. The remarkable composition of the photo relies on 1940s magazine styles to set itself apart from traditional photography generally requested by timber companies. Ray's experience in ski photography helped him capture the action, adjusting the shutter just enough to allow for clear focus throughout. Considering the flat lighting, timing and exposure of this shot would be challenging even today. Ray used a press camera with the fastest film then available—ASA 100.

(4" x 5" negative #3814H)

Fishing Boats at Diamond Lake
Circa late 1930s. Diamond Lake
lies just north of Crater Lake in
Douglas County.
(4" x 5" negative #2723)

Mountaintop Experience
Fall 1932. On February 5,
1933, the rotogravure section
of Rhode Island's *Providence
Sunday Journal* published this
almost surreal mountaintop
scene shot on Mount Hood.
(9 x 12 cm negative #294)

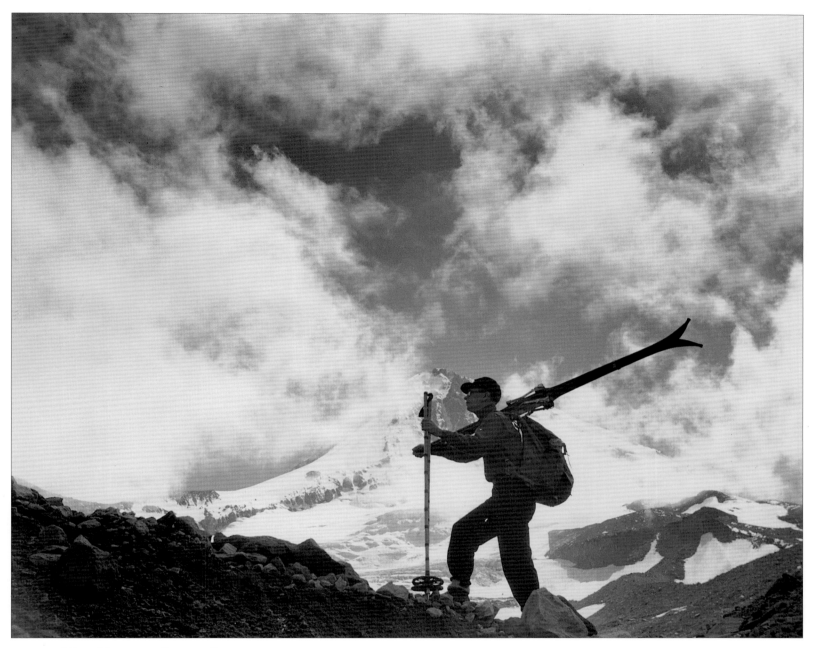

Eliot Moraine, Cooper Spur
June 1936. Hal Lidell, a member of the
Oregon Camera Club, was a frequent
mountain climbing companion of Ray's.
(9 x 12 cm negative #1274)

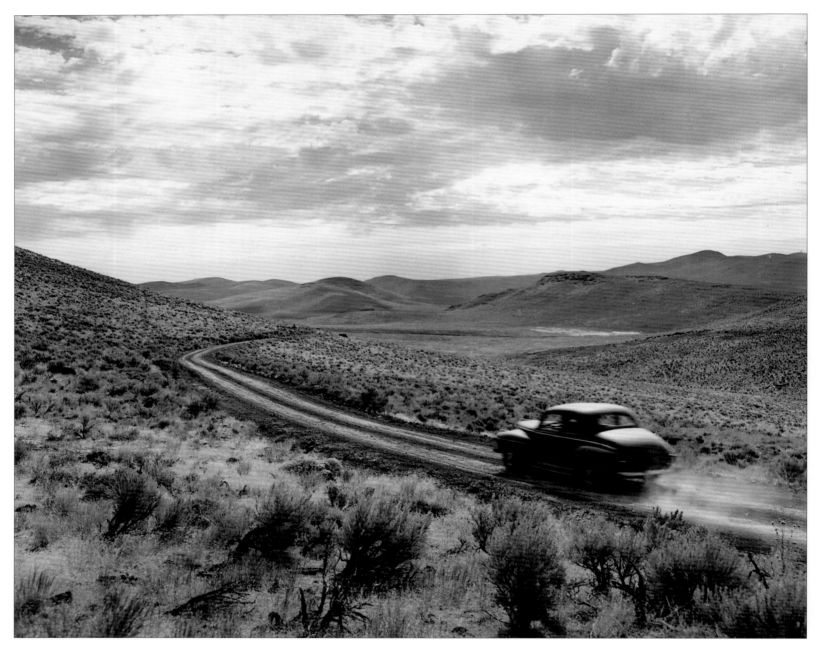

Desert Road
1944–1945. Photographed near
Burns, the road into the high desert
was (and still is) a solitary one.
(4" x 5" negative #4128B)

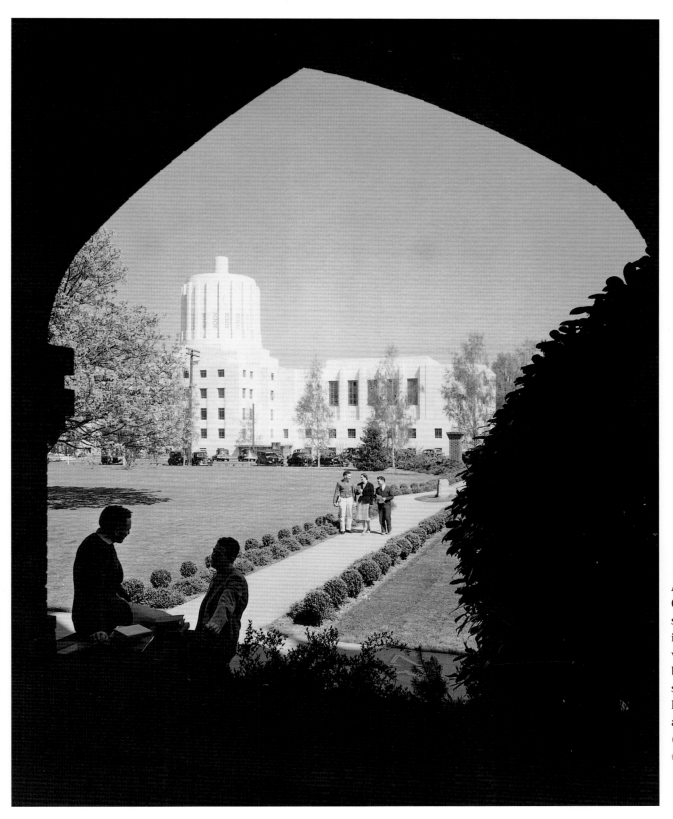

Willamette University, Salem April 19, 1938. Construction on the state capitol building in the background was almost finished, but the heroic gilded statue, *The Pioneer,* had yet to be installed atop the dome. (8" x 10" negative #PA19425D)

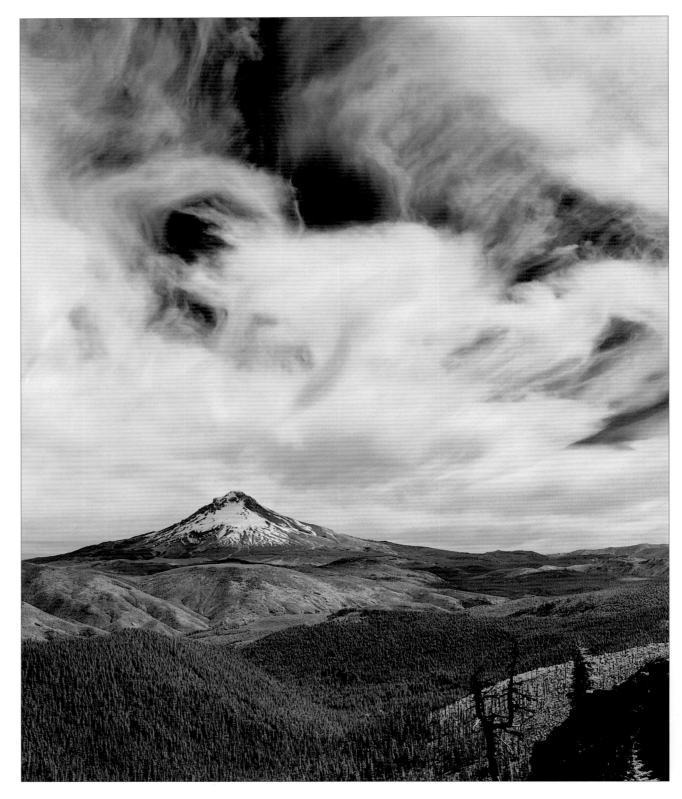

Mount Hood from High Rock
1940. High Rock, with an elevation of 4,953 feet, provides a panoramic view of the south face of Mount Hood.
(4" x 5" negative #3077)

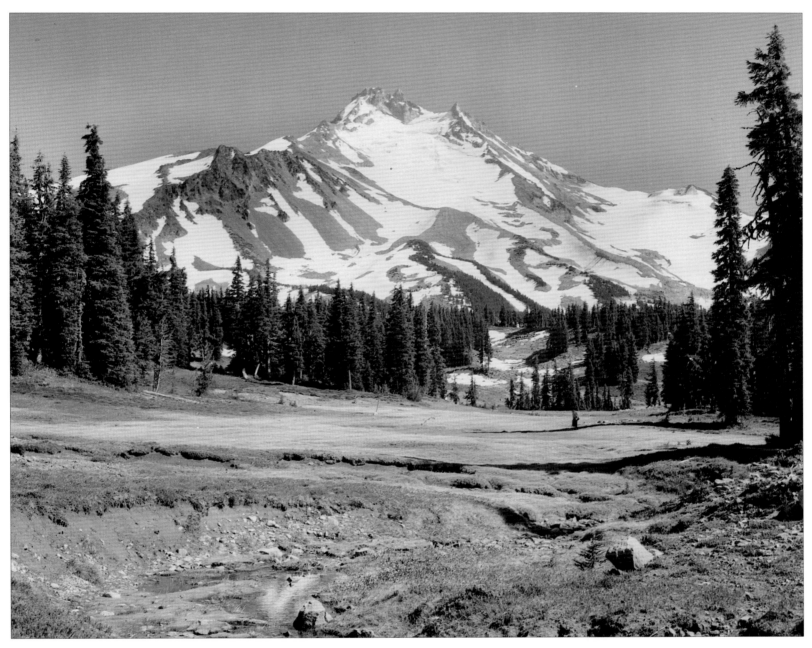

Mount Jefferson from Port Ridge
Circa early 1940s. Views such as this could only
be seen by those willing to scale the heights.
Always in search of the next breathtaking scene,
Ray became a founding member of Wy'east, a
mountain climbing club. (4" x 5" negative #3788)

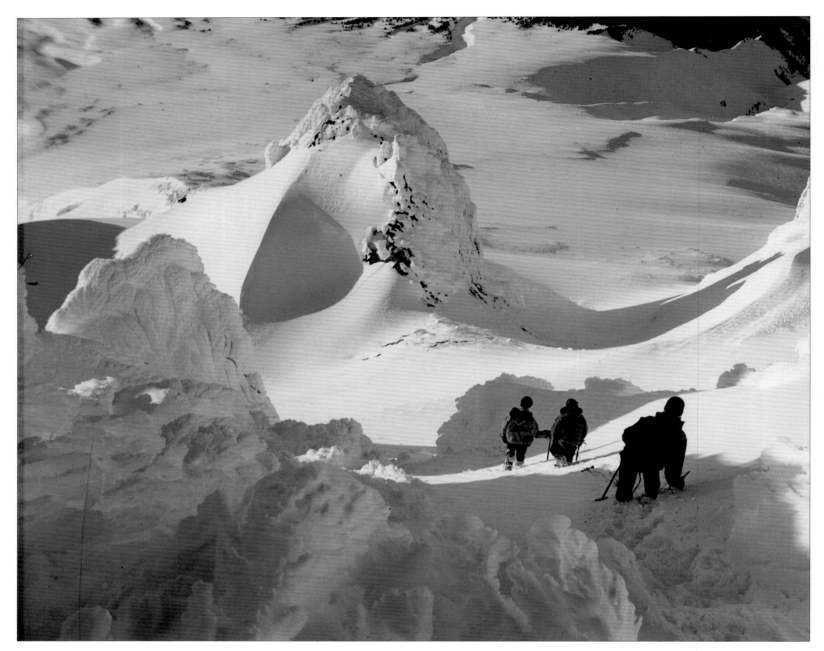

Starting Down

January 13, 1933. Throughout the 1930s, an annual ritual in Oregon was the first Mount Hood climb of each year. Mountain climbers vied for the honor, and Ray and Mira's party became the first group in 1933 to place their names in the register book kept on the summit. Ray made the shot of Ralph, Ole, and Mira as they began the chilly eight-mile descent from their mountaintop campout. This was one of Ray's first nationally published snow pictures. (9 x 12 cm negative #308)

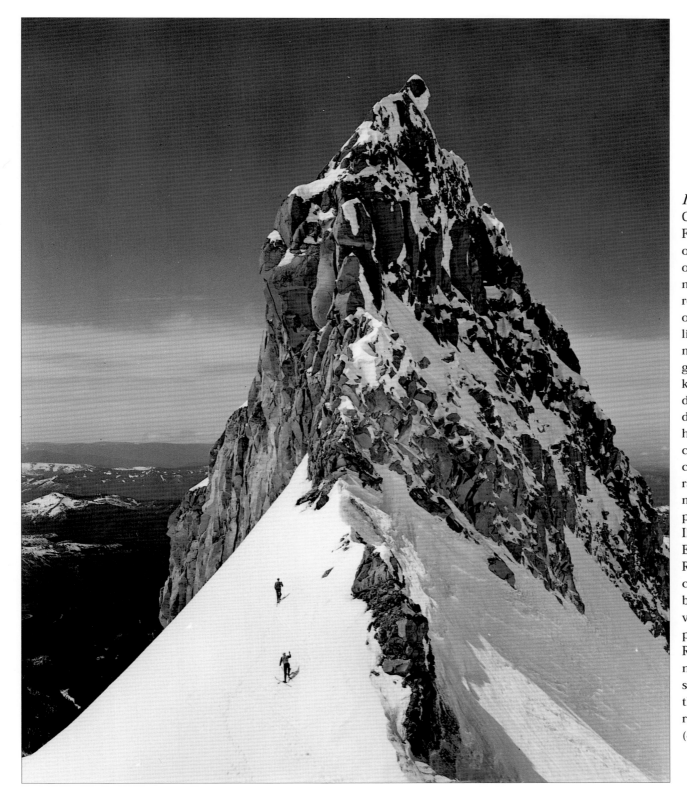

Illumination Rock
Circa early 1940s. For Portland's Fourth of July celebration of 1887, plans were made to carry enough red powder to the top of Mount Hood to light the entire summit. When climbers got bogged down in knee-deep snow, they decided to ignite the display from the highest rock they could. The display could be seen for a radius of one hundred miles. The launch pad was later named Illumination Rock. Early stories of the Rock had to use copies of old photos by O. C. Yokum, who was an early Portland photographer. When Ray began his career, newspapers eagerly sought his images for their high-quality rotogravure sections.
(4" x 5" negative #3576A)

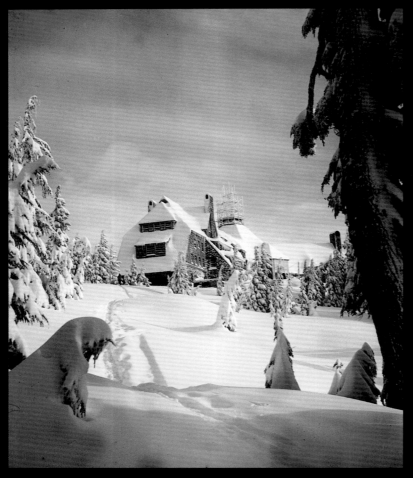

Timberline Hotel
Fall 1936. Construction of Mount
Hood's Timberline Lodge began on
June 13, 1936. By fall, the wings
were finished, and the central "head
house" was nearing completion.
(9 x 12 cm negative #1454B)

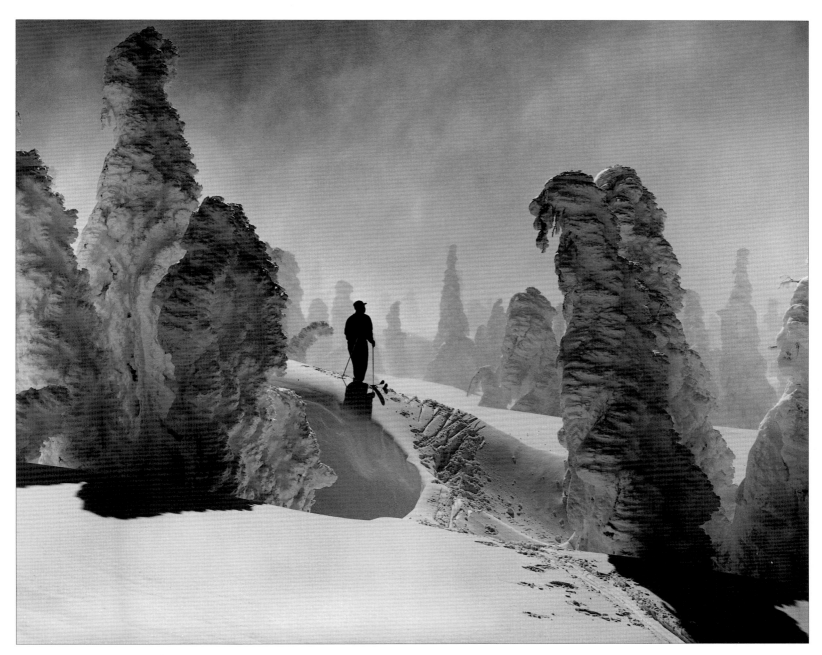

Windstorm at Timberline
1955. Mira, who was a photographer in her own right, frequently went with Ray to take pictures. She took this photo of Ray on skis at Timberline, Mount Hood.
(4" x 5" negative #7430A)

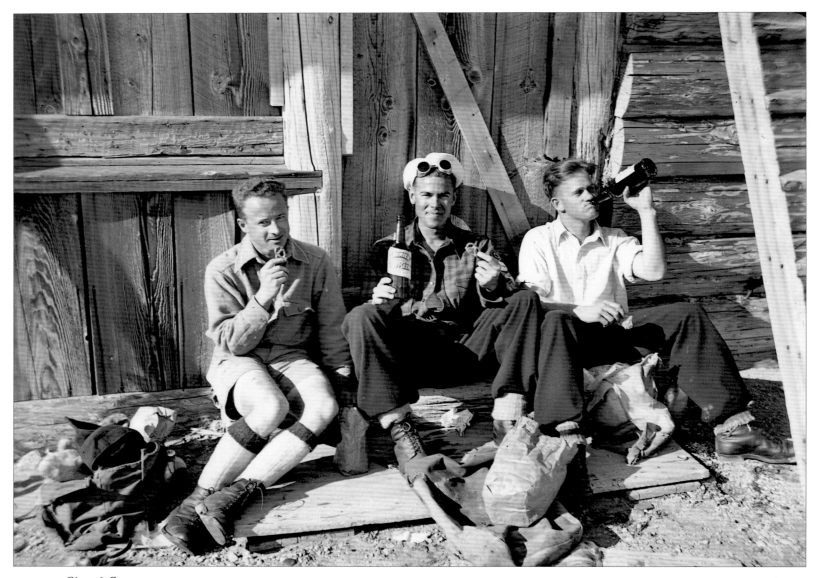

Cloud Cap
Circa 1933–34. Climbers
enjoy beer and pretzels at
Cloud Cap. The beer is
Rainier. Cloud Cap Inn, at
5,985 feet, was opened in
1889. Built of logs, it was
anchored to the mountain
with cables.

(9 x 12 cm negative #640)

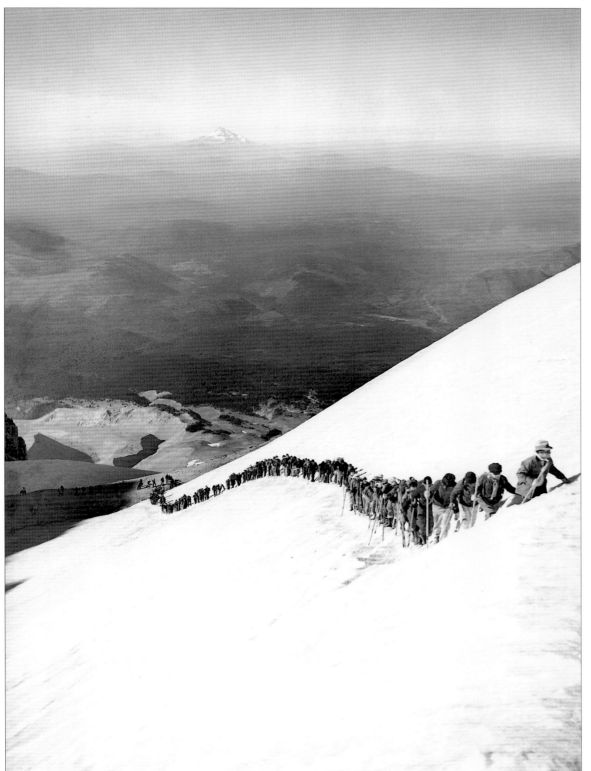

Mantle Club Climbers
Undated. Prior to
World War II, climbing
Mount Hood in a huge
"follow the leader"
style was a popular
weekend activity.
The Mantle Club was
founded in 1933.
(6 x 9 cm negative #1320A)

Mount Hood from Timberline Road March 29, 1936. *Camera Craft* used this image, entitled "Skier's Heaven," for its February 1940 cover. It was also a prize-winning photograph in the 1940 Kodak Exhibition. (9 x 12 cm negative #1180C)

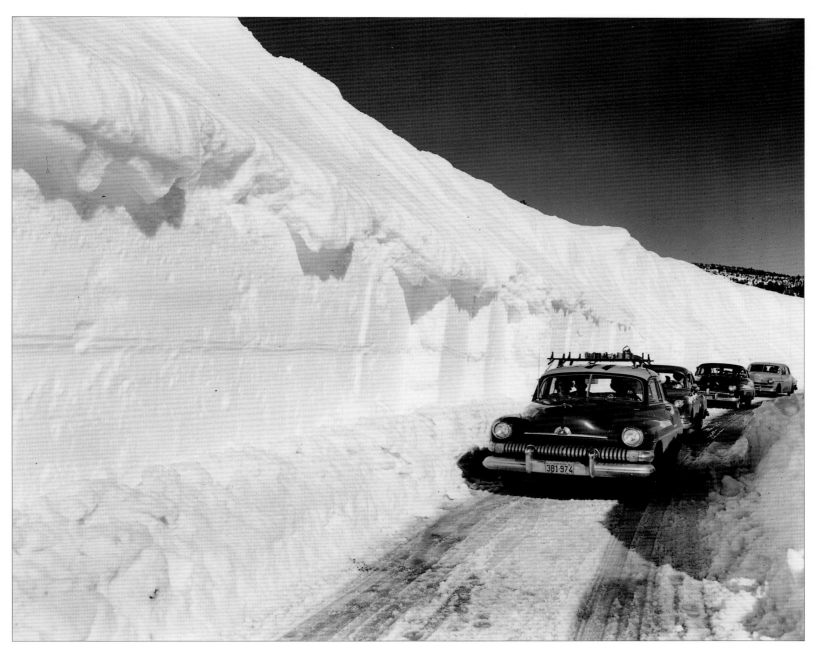

Timberline Highway, Mount Hood
Circa 1951. Ray noticed that publishers juxtaposed his landscapes with stock photos of motorists enjoying their new cars. By the late 1940s, he was aiming his lens at both the beauty and the beast. The frequent delays on the one-lane road approaching Timberline afforded him an opportunity to get this picture. When Ray was working on an important assignment from a national magazine, he would remove the cars' license plates so they would not date the image, as the 1951 tags do here. (4" x 5" negative #6660C)

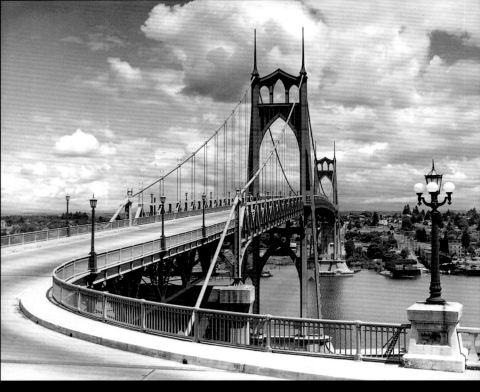

St. Johns Bridge
Undated. Designed to exhibit a "cathedral" aspect, the St. Johns Bridge in Portland was erected between 1929 and 1931, just a few years before the Golden Gate Bridge. The bridge's design engineer, David B. Steinman, commented, "It is the ethical duty of the builders to make bridges beautiful as well as useful."

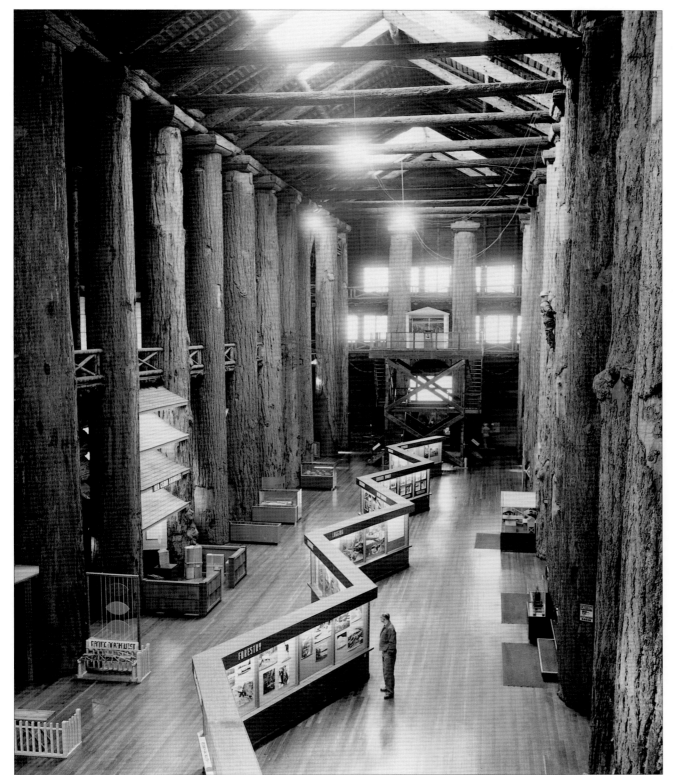

Forestry Building Interior
Circa late 1950s. Built as an exhibit for the 1905 Lewis & Clark Fair in Portland, the Forestry Building was the largest log building in the world. Old-growth trees were selected for perfect logs of exact size; loggers devised ingenious schemes to move them without using chokers, in order to preserve the bark. At every step, the fellers, buckers, riggers, boom men, and carpenters all took special pride in their work. Called the "Timber Temple," its meditative atmosphere was described as an intense silence. On August 17, 1964, the silence was disrupted by a roaring inferno that consumed the structure.
(4" x 5" negative #7569)

Multnomah County Library
1930. Ray learned architectural photography with a little advice and a lot of practice on a borrowed view camera. He photographed buildings as an exercise to learn the complex camera adjustments required to correct architectural distortion. If a conventional camera had been used to make this image, the building would appear to be falling over backwards. Architectural cameras keep the film parallel to the building to avoid such distortion. (5" x 7" nitrate negative #S13A)

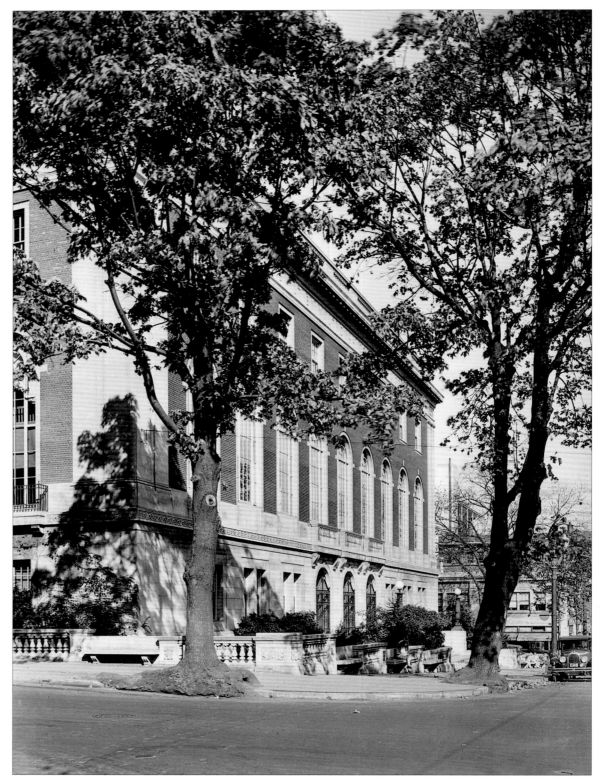

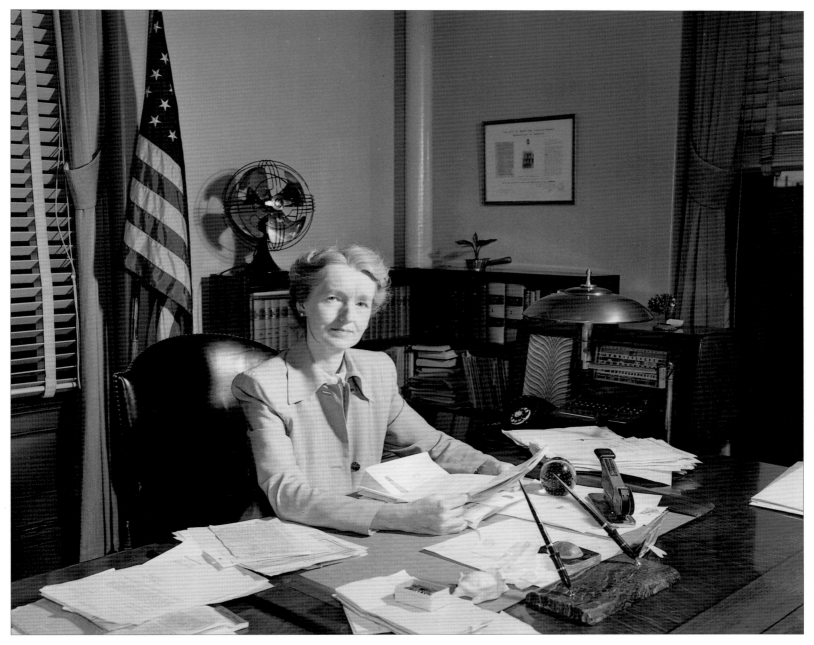

Portland Mayor Dorothy Lee
Circa 1949. Dorothy McCullough Lee began a small legal practice in Portland in 1924, and in 1928 took a seat in the Oregon House. As mayor of Portland from 1949 to 1952, her efforts to curtail corruption and criminal violence were largely successful. Throughout her career, she earned a range of nicknames, including "Portia," "Dauntless Dottie," and "Dottie-Do-Good." (4" x 5" negative #6502A)

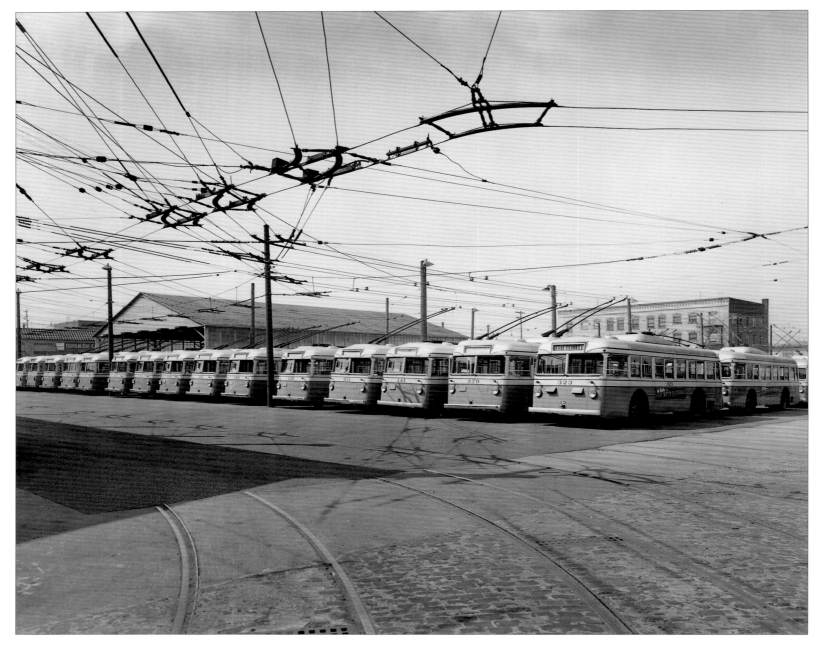

Trolley Buses
April 18, 1939. Trolley coaches once parked at the car barn on the north side of East Burnside at 27th Street. This site is currently occupied by a restaurant and a bank.
(8" x 10" negative #PA 24608)

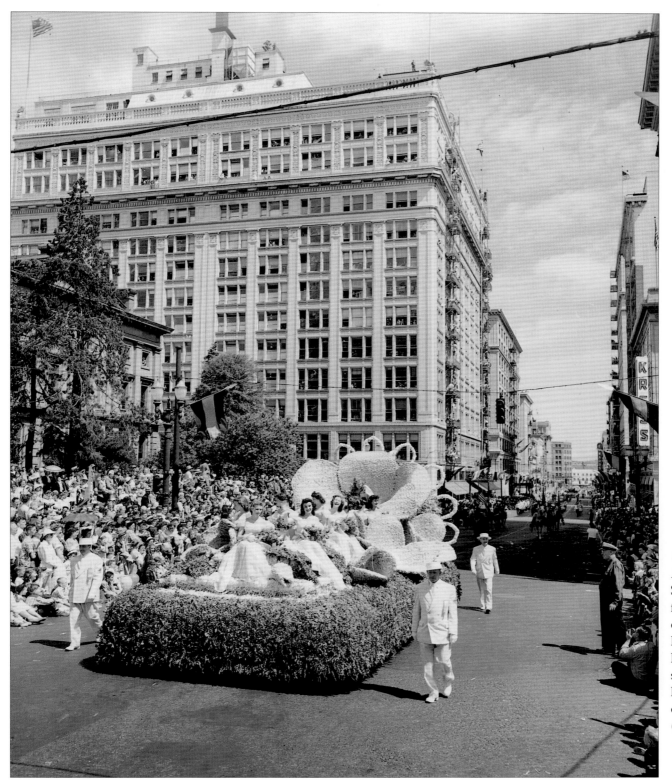

Queen's Float in the Rose Parade
Summer 1949. The float approaches the corner of Southwest Fifth and Yamhill. Pioneer Courthouse stands on the left. Meier & Frank is in center background.
(4" x 5" negative #6182)

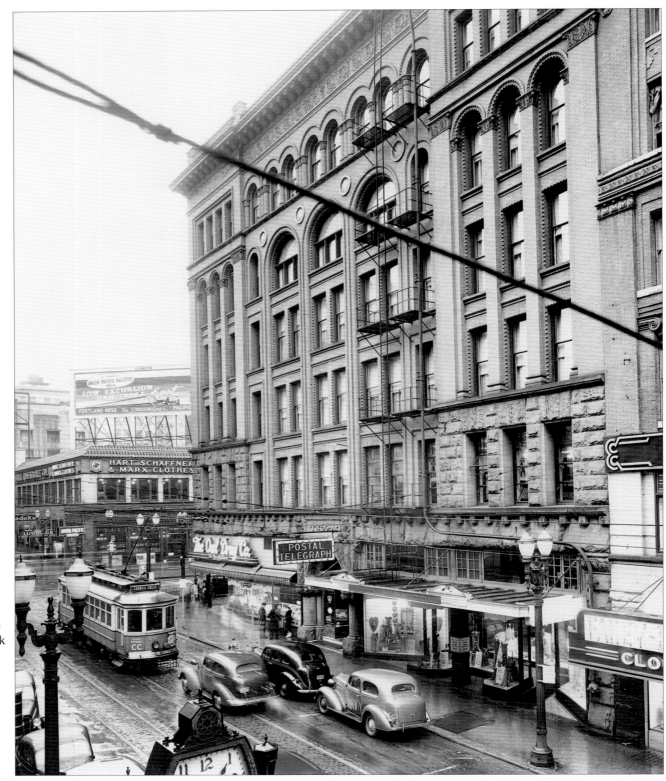

Imperial Hotel
Undated. The west-bound Council Crest trolley passed Southwest Broadway at 12:45 on a rainy afternoon. A fire escape on Washington Street, just a two-block walk from the Photo Art Studio, offered this vantage point.
(8" x 10" negative #PA23656)

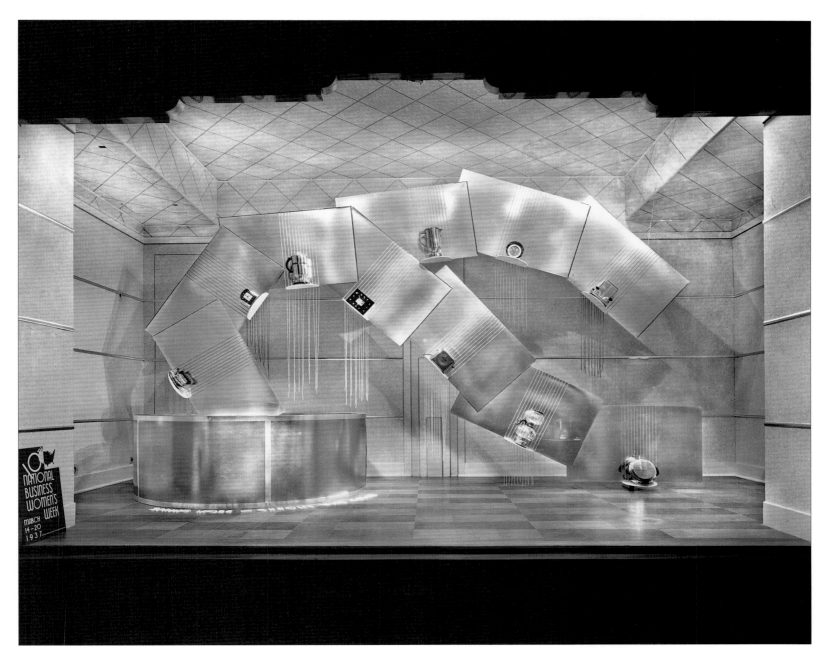

Windows in the Selling Building

March 12, 1937. Art deco desks, clocks, and coffee pots formed part of a window display at 621 Southwest Alder in downtown Portland during National Business Women's Week. The surrealistic arrangement was intended to demonstrate "Spring Mode—Chrome with Color." The photo was commissioned by lumber brokers Dant & Russell, who instructed Ray to "show as much of the ceiling as possible" to promote their woodwork. Longtime Photo Art employee Larry Smith recalls: "We took these photos at night. We unrolled a huge roll of canvas behind the photographer to keep car headlights from reflecting in the window." (8" x 10" negative #PA14751A)

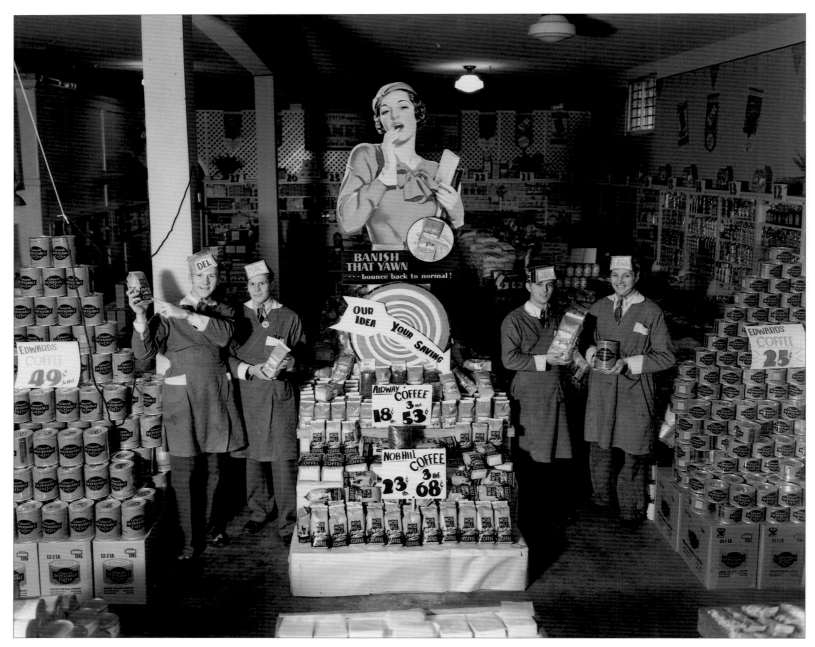

Pay 'n Takit

Circa early 1930s. Ray spent a day parading these "grocers" around various stores to photograph the "Banish That Yawn" campaign for the Edwards Coffee Company. Ray photographed all kinds of similar setups in the hundreds of small chains that proliferated before an industry war, combined with the Depression, decimated independent grocers. Pay 'n Takit was a chain of five small grocery stores, but by 1933 they were not around to smell the coffee. This building, at 1180 Union Avenue just north of Killingsworth, is also gone. Union Street was later renamed Martin Luther King Jr. Boulevard. (8" x 10" nitrate negative #PA6600A)

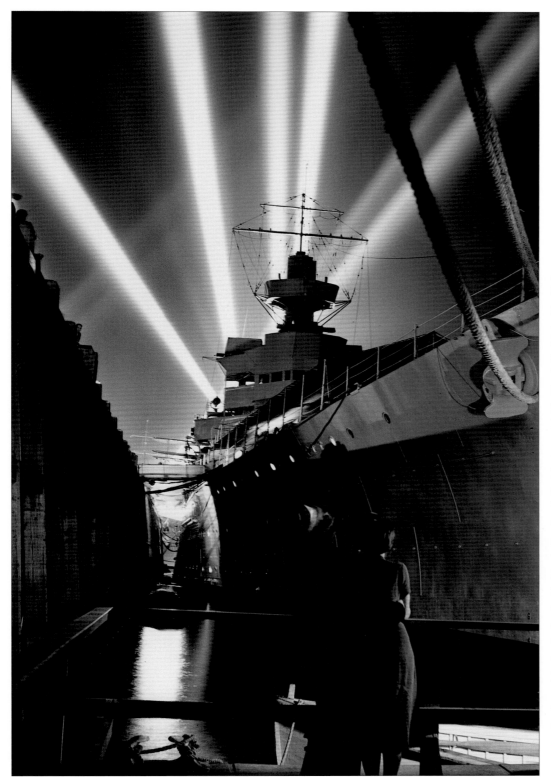

Fleet Week
Summer 1937. Ray joined fellow Photo Art photographer Bill Vernon in shooting images of Fleet Week. Navy warships beamed their searchlights every night between 9:30 and 10:00. For the last ten minutes, the lights remained stationary for the benefit of thousands of picture takers who aimed their Kodaks at the brilliant display. Ray and Bill took nearly identical shots of this couple. Vernon scored the front page of the July 25, 1937, *Oregonian* with his photo, captioned "Lights in the Night— Girl in the Arms."
(6 x 9 cm negative #1888)

*Commercial Iron
Works*
January 22, 1944.
Commercial Iron
Works chose this
photo for the cover
of the February 5,
1944, issue of their
official publication,
The Porthole.
(4" x 5" negative
#PA57101-15)

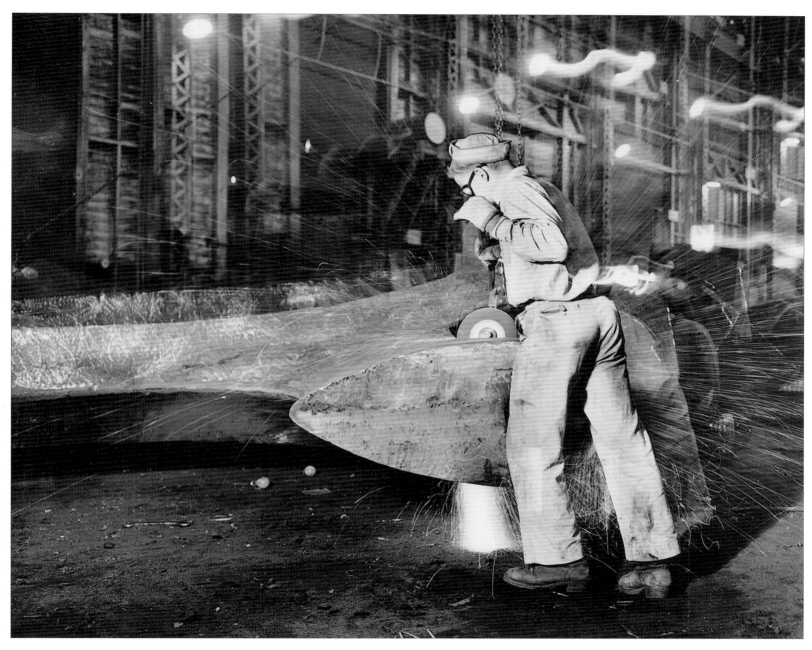

Columbia Steel Casting, Machinery and Operations

July 25, 1944. Photo Art was commissioned to shoot industrial photos of Columbia Steel Casting. In the course of one busy afternoon, Ray took well over a hundred photographs of the machinery, workers, and operations, including this propeller grinder. The wartime factory was located in Portland's Montavilla neighborhood, between Northeast Glisan and Halsey on 55th. Ray made an ambitious and successful attempt to combine ambient light with a flashbulb exposure using a handheld Speed Graphic camera. The busy war production schedule did not allow him any time to set up a tripod. (4" x 5" negative #PA64209-49)

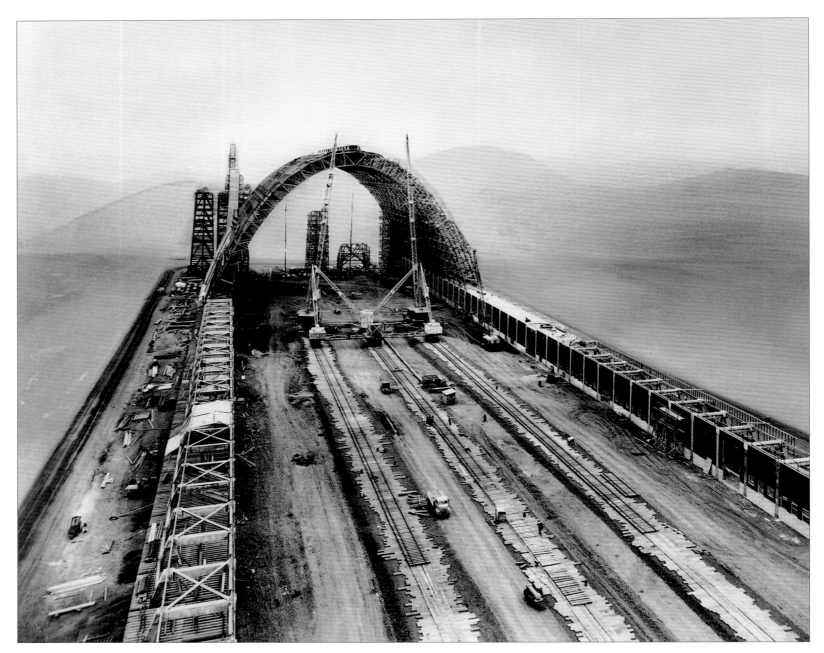

Timber Structures
Summer 1943. Ray was asked to photograph many
of the shipyard plants that Timber Structures built.
The image reproduced here was retouched by studio
staff artists to remove the surrounding area, which
was shipyard construction as far as the eye could
see in any direction. (8" x 10" copy negative #PA50642-9,
filed as #PA53152. Original airbrushed print filed as #51318.)

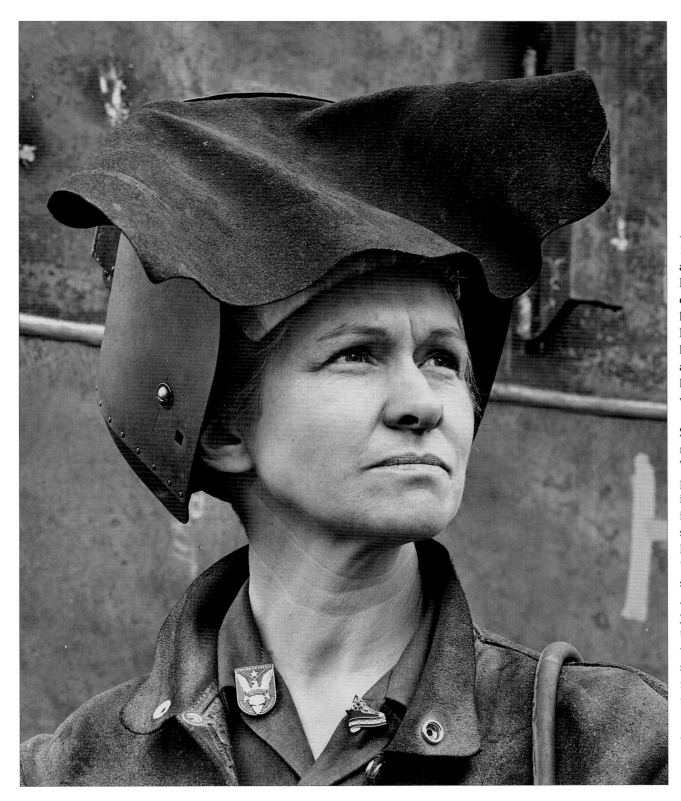

Mary Carroll
1942. Just six months after Pearl Harbor, Ray photographed an eloquent day-in-the-life essay, following Mary Carroll as she hitchhiked to work and photographing her daily routine as a welder. *The Bo's'n's Whistle,* the Oregon Shipyard's in-house magazine during World War II, published this photo in its August 13, 1942, issue. The article states that Mary and her housemate were "the first women shipworkers in America's maritime yards." Mary joined the shipyard crews when her eldest son was listed as missing in action in the Philippines.
(from vintage print, Atkeson family collection)

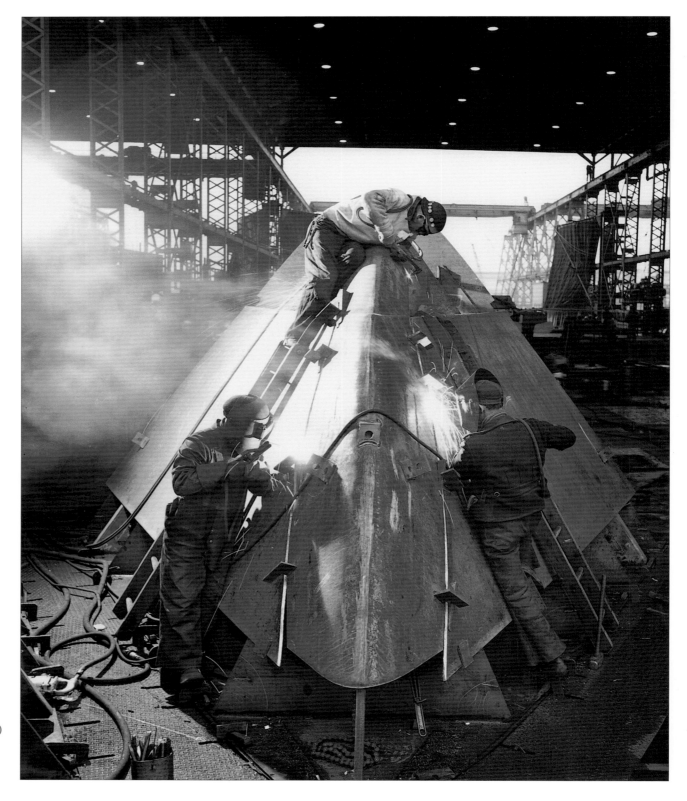

Portland Shipyard
January 4–9, 1943.
Ray took thousands
of photographs
that document ship-
building in Oregon
during World War II.
(4" x 5" negative #3688C)

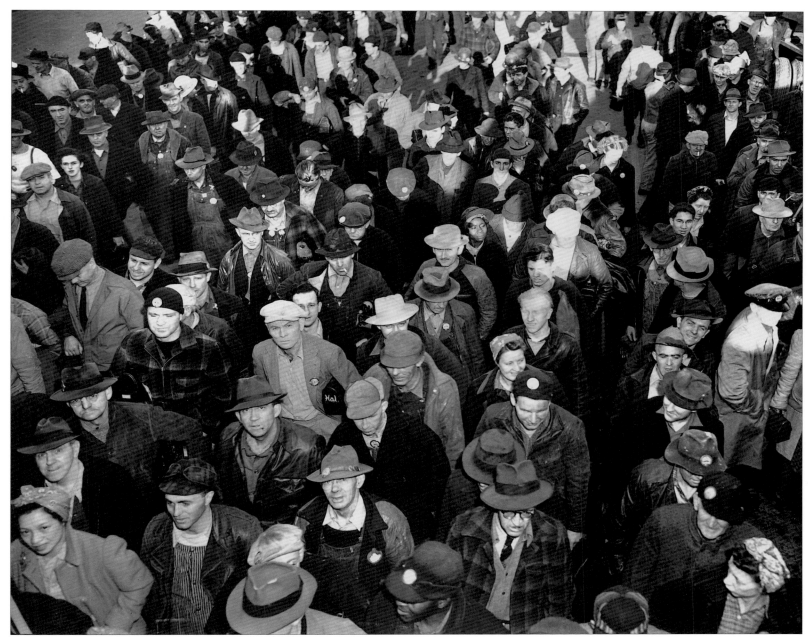

Commercial Iron Works
January 22, 1944. An endless stream of workers headed for the gates at shift change. Bottleneck delays were caused by wartime security checks. Another Photo Art employee left Ray a note on the job order advising: "guards nicer at #2 gate."
(4" x 5" negative #PA57101-19)

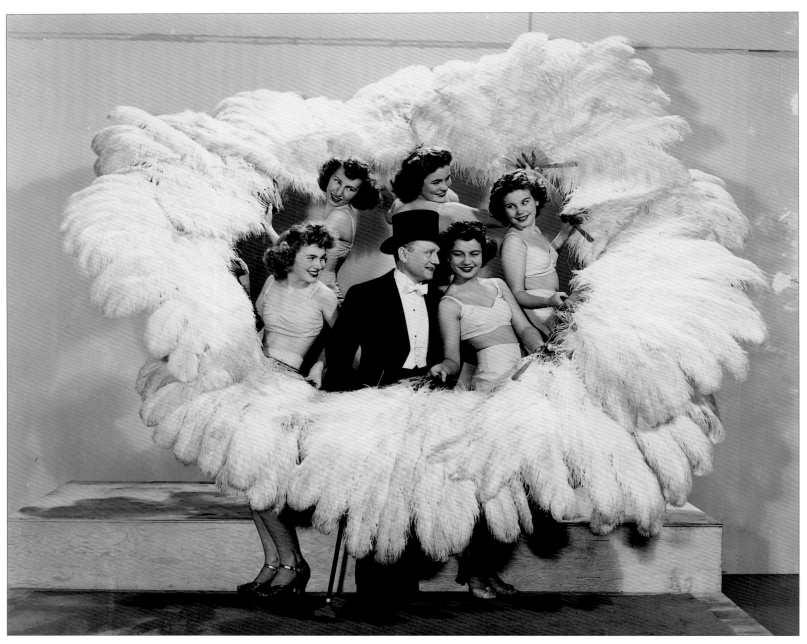

J. & J. Cast
March 28, 1944. Frank Nylander
Advertising commissioned this
photo, taken in the Photo Art Studio.
(8" x 10" negative #PA60382-1)

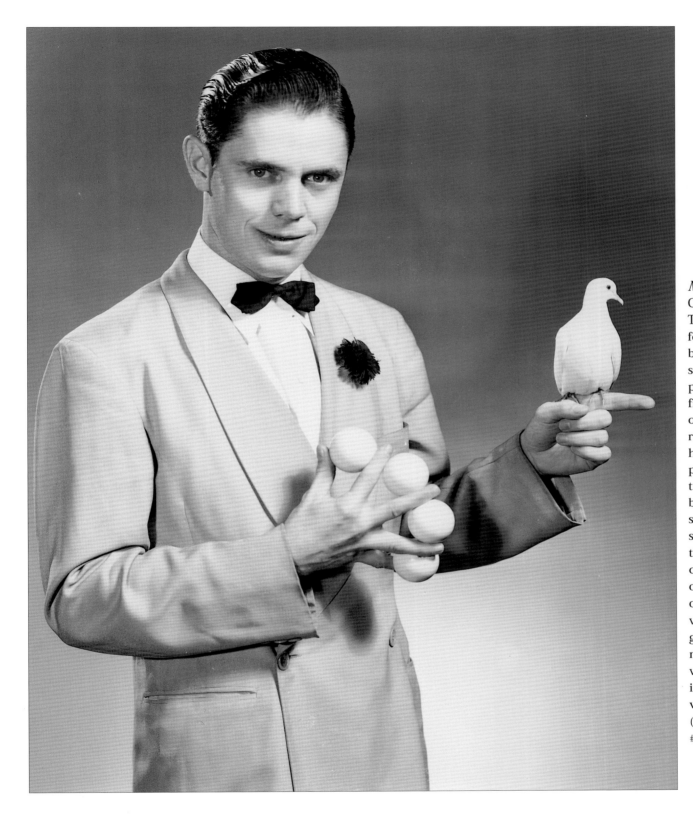

Magician
October 30, 1942. To obtain prints for publicity and booking engagements, show business personalities were frequent customers of portrait photographers. Hollywood had redefined studio portraiture just twenty years earlier by showing movie stars while they were smiling, rather than the somber faces common at the turn of the century. One of the current trends when this photograph was taken of magician Bob Clark was "high-key" lighting, resulting in a very bright picture. (8" x 10" negative #PA45119-2)

Two Comedians
March 28, 1944. Frank
Nylander Advertising
commissioned photographs
of these two comedians.
(8" x 10" negative #PA60382-7)

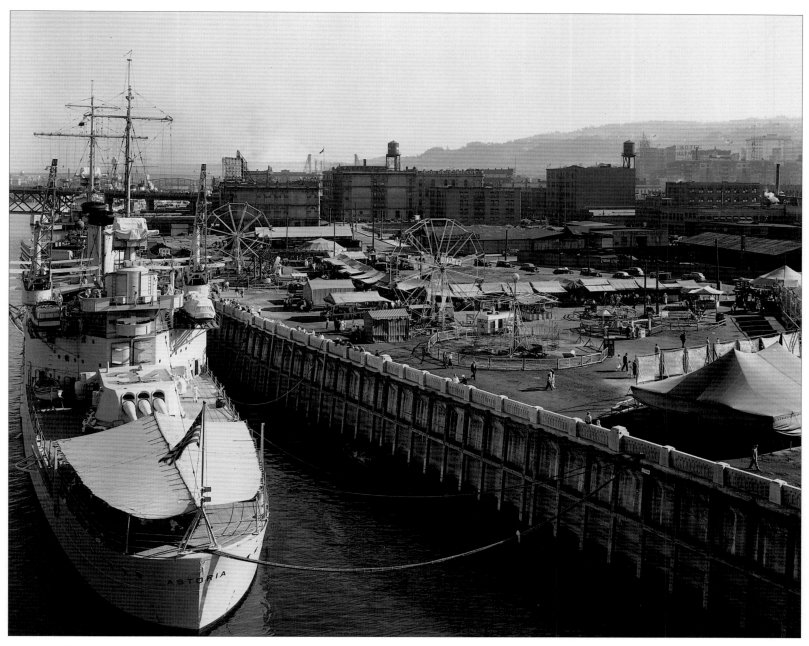

Ziegler Shows

July 1937. Navy battleships anchored in Portland's port for Fleet Week, a series of parades, ceremonies, and festivities lasting ten days. This carnival amusement center occupied four acres of Waterfront Park at Northwest Flanders and the Steel Bridge.

(8" x 10" negative #PA16456-H)

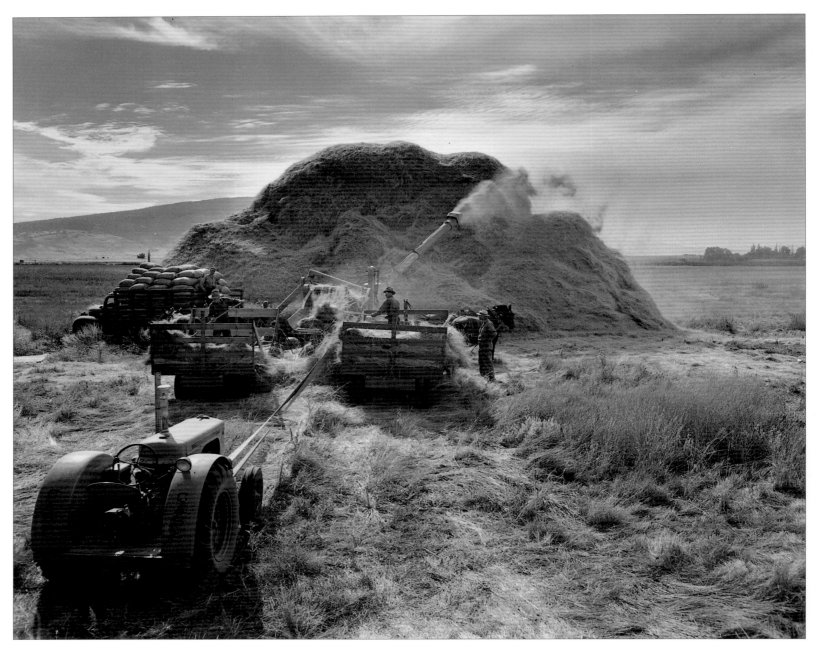

Threshing Grass
Circa 1945. Grass was and
remains an important harvest
in the Grand Ronde Valley.
(4" x 5" negative #4083)

Oregon Mutual Life Insurance

Circa 1935. The models look relaxed, but Ray was probably working at top speed because they had pulled over on the Columbia River Highway after a blind curve coming off the bridge at Shepperd's Dell. The view of Bishop's Cap is so photogenic that many Kodak moments have been spoiled by rear-end collisions. Soon after this photo session, the highway department added "No Stopping" signs to the scene. (8" x 10" nitrate negative #PA9634)

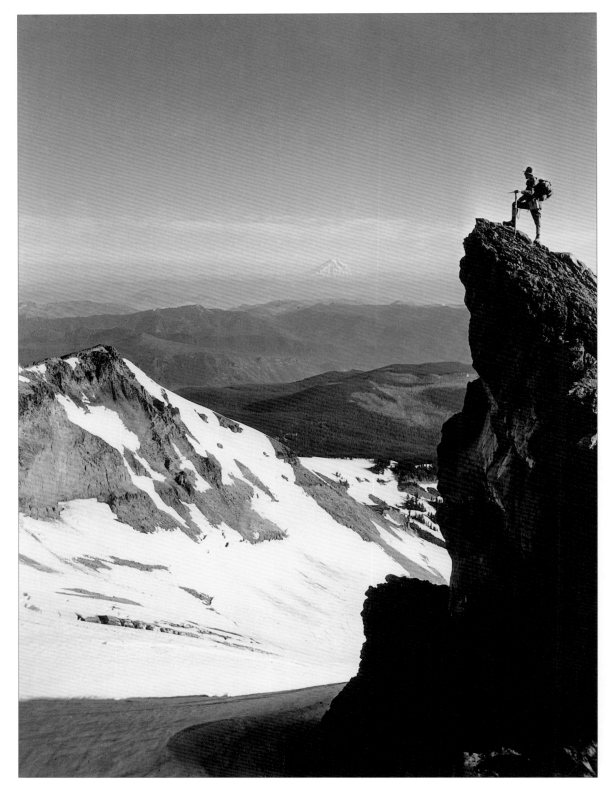

Top of the Mountain
Circa early 1932. Ray took this photo of his friend Al Monner on a point above Barrett Spur on Mount Hood.
(9 x 12 cm nitrate negative #175)

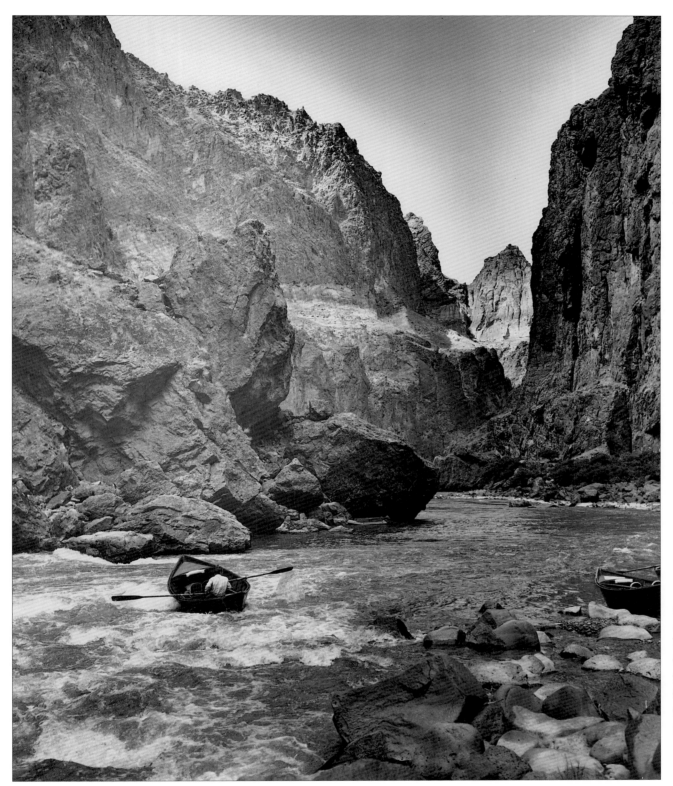

Owyhee River Gorge
Undated. The Owyhee River runs through Malheur County in eastern Oregon.
(4" x 5" negative #8726A)

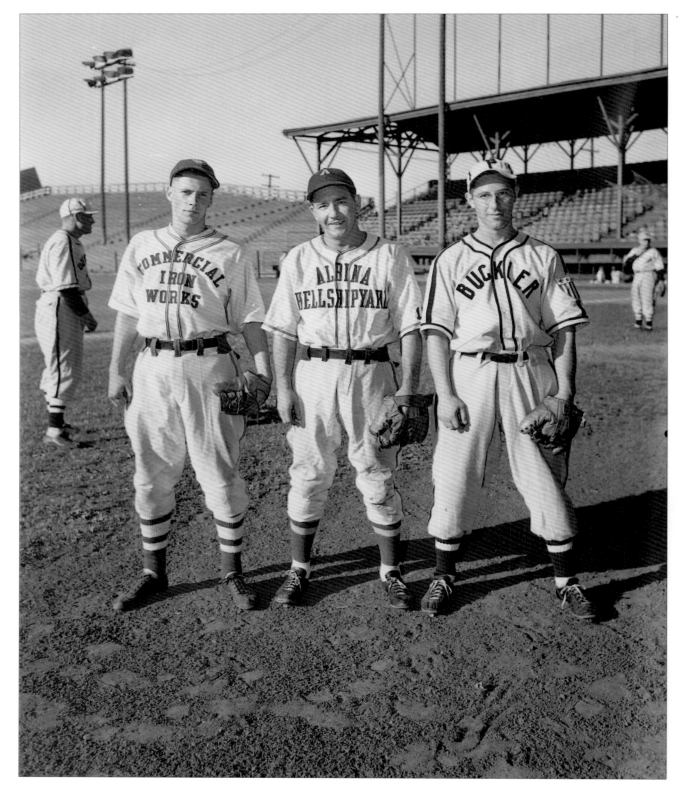

Baseball Players
July 13, 1943. The Buckler Chapman Company sponsored its own company baseball team. The location is the old Northwest Vaughn Street Baseball Park in Portland.
(4" x 5" negative #52078)

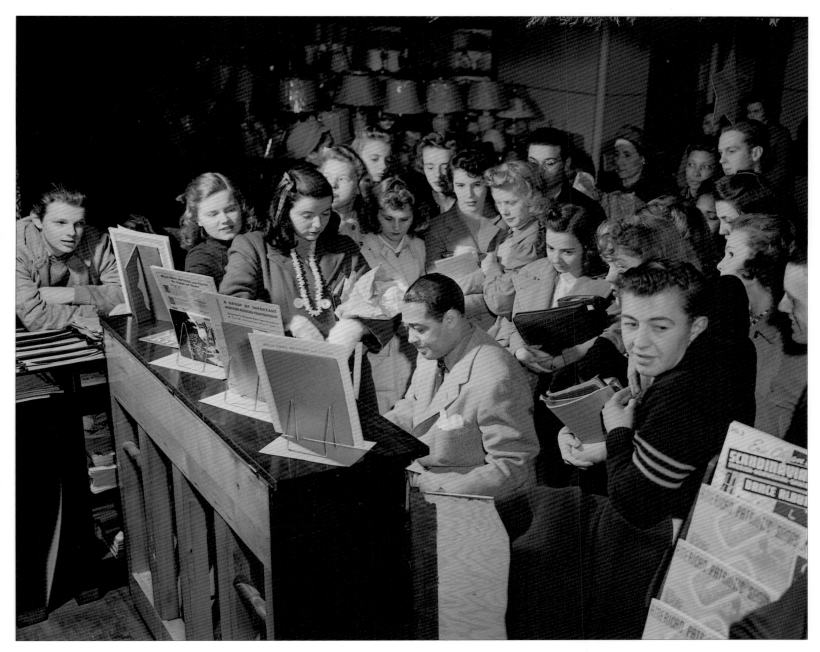

Duke Ellington

December 9, 1941. RCA Victor recording artist Duke Ellington performed at Portland's Mayfair Theater December 8–14, 1941. He autographed records in J. K. Gill's record department December 9, just two days after the Pearl Harbor attack that brought America into World War II. Here Ray utilized what he called "cross lighting," using two flashes—a strong flash coming in from the side at a low angle and a slightly smaller flash on the camera to fill in shadow detail. (4" x 5" negative #PA37647-1)

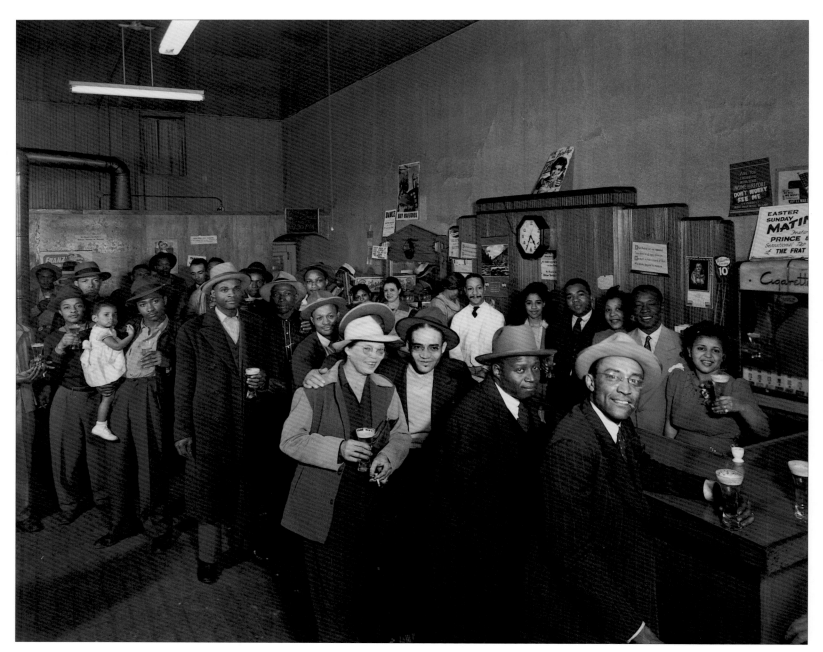

301 Restaurant

April 28, 1943. Sloping down the east bank toward the train yards and river, the land where the Convention Center, Rose Quarter, and Coliseum now stand was once a mostly African-American section of Portland's inner city. From the 1950s until the early 1970s, urban renewal meant clearance, and the neighborhood was bulldozed, leaving few original structures. Located at 301 Northeast Flanders Street, the 301 Club and all of the surrounding blocks were razed to make room for the I-84 eastbound entrance from I-5 northbound. (8" x 10" negative #49235)

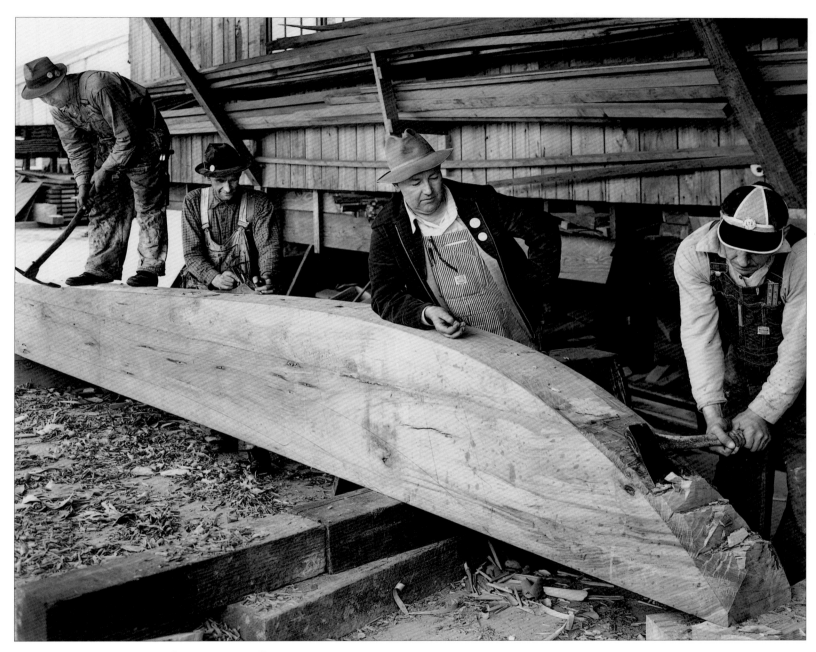

Astoria Marine Construction Company
May 27, 1942. At the beginning of World War II, the military drafted marine operations throughout the coast to construct whatever boats they were capable of building. The Astoria Marine Construction Company's workers, shown here wearing their Payday overalls and AFL union badges, were craftsmen who developed their skills over generations. Wartime censors destroyed four of the negatives Ray took that day. No reason was given. (8" x 10" negative #40544-8)

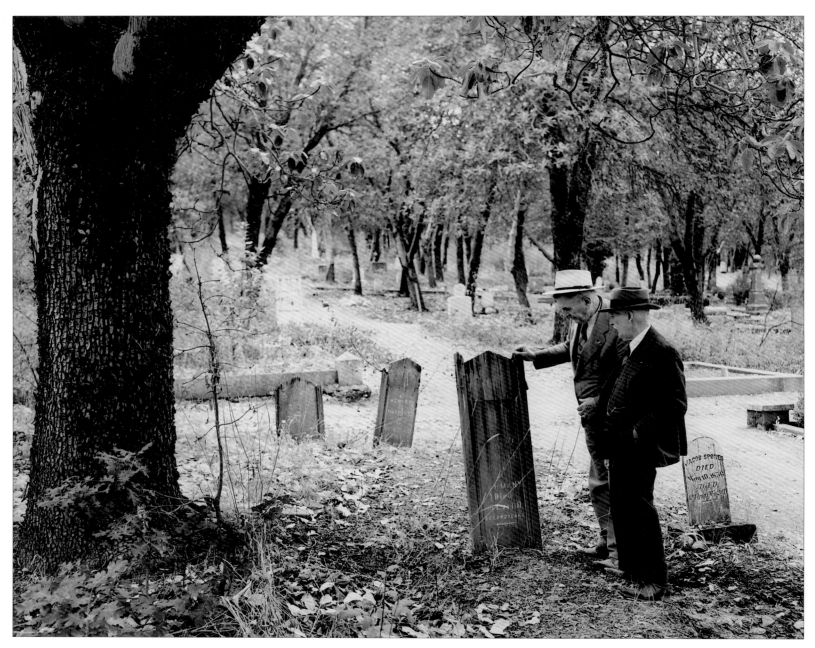

Jacksonville Cemetery
1945. Ray took this photo of photographer
Emil Britt and his friend Judge Lovelle in
the Jacksonville Cemetery. Britt was the
son of Peter Britt, a pioneer photographer
who established a daguerreotype studio in
Jacksonville in November 1852.
(4" x 5" negative #4145)

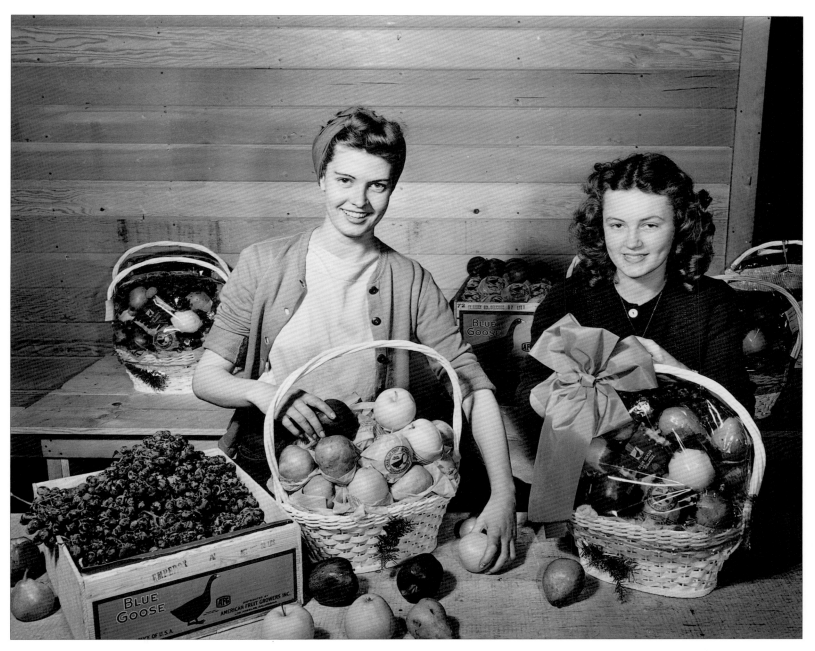

American Fruit Growers Association
December 4, 1944. Ray generally used professional models for this
kind of shot, but that proved impossible when the job site was a
drafty frame warehouse in Medford, 277 miles away from Portland.
During the height of World War II, the Blue Goose packing ware-
house employed hundreds of women in their packing lines. Ray's
photo session enabled these two workers to enjoy a break from the
normally frantic Christmas production rush. (4" x 5" negative #PA68262-8)

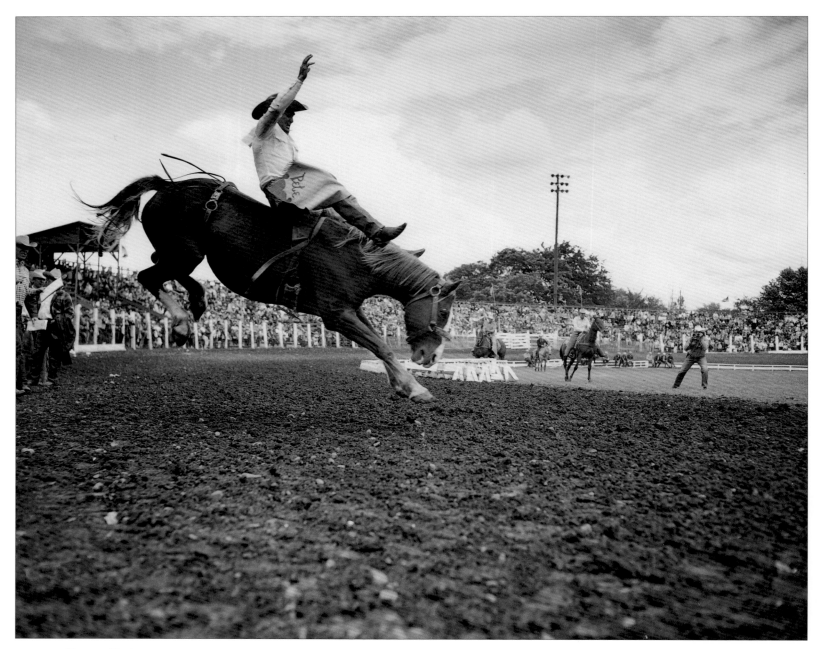

Bronc Riding
1955. The Pendleton Round-Up
has been an annual event since
its founding in 1910.
(4" x 5" negative #7394B)

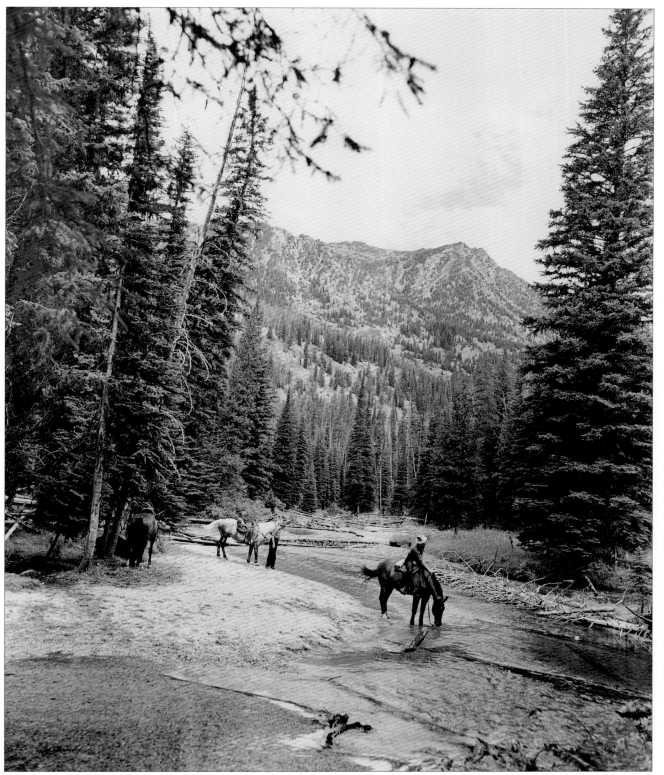

Horses in the Wallowa Mountains 1945. *National Geographic* asked Photo Art Studio to shoot a feature story on Oregon. Ray spent three months traveling around the state and decided while on this trip to begin his freelance career. He brought his 4" x 5" cameras and shot thousands of extra pictures for his files. This picture was taken in the Wallowa Mountains' Eagle Cap Wilderness Area.
(4" x 5" negative #4075A)

Crashing Wave
Summer 1938. The *Oregon Journal*'s Sunday rotogravure section published this photo with the caption, "Ruth Elster in a cove at Cape Kiwanda."
(6 x 9 cm negative #2321A)

Boiler Bay State Park
Circa 1950. Just north of
Depoe Bay on the central
Oregon coast, Boiler Bay
State Park borders a wild
sweep of rugged shore.
(4" x 5" negative #6288C)

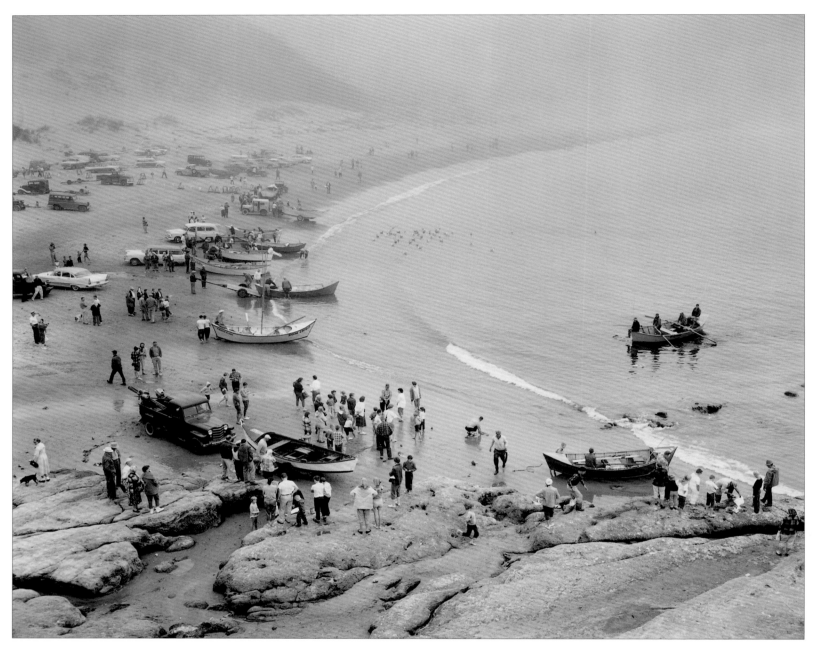

Cape Kiwanda

1960. The light was not good this day, and Ray exposed
just one negative and went home. He wryly noted
that, more often than not, he would travel hundreds
of miles to photograph a scenic location only to find
the light not to his liking. Two years later, one of his
dramatic color shots of surf at Cape Kiwanda was used
by *Life* magazine for a cover. (4" x 5" negative #7709A)

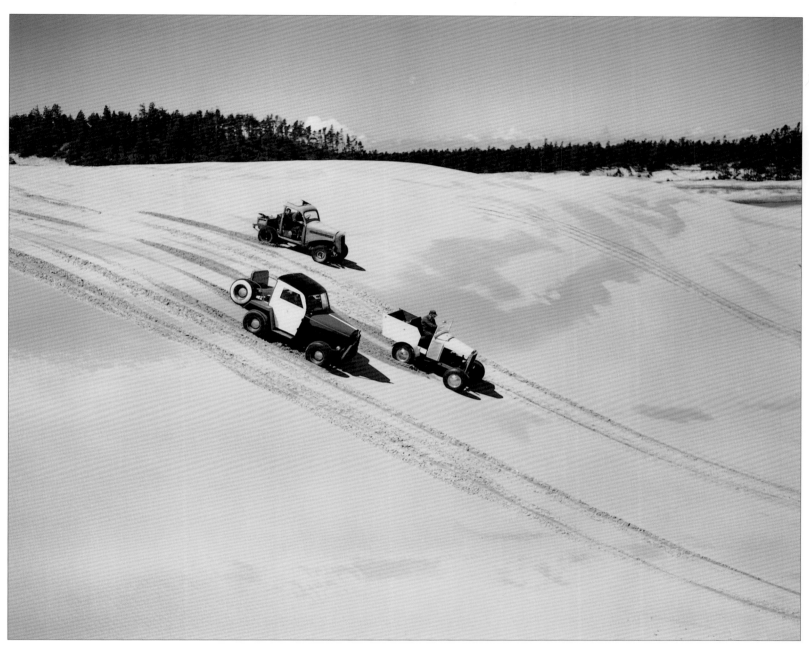

Sand Buggies
1960. These "open jalopies equipped with huge tires"
were racing on the sand dunes south of Honeyman
Park near Coos Bay. Three years later, Ray was finally
able to sell the image of the homemade, off-road
vehicles to the California Automobile Association,
which published a travel article about the central
Oregon coast. (4" x 5" negative #7684C)

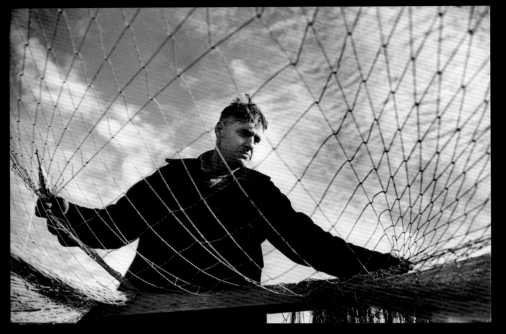

Mending Nets

1937. Over a span of several days, Ray made hundreds of images in Astoria on his newly acquired Zeiss Super Ikonta C camera. The camera took eight exposures on a roll of film and was much faster to use than his bulky sheet film camera, enabling him to work without a tripod or the usual posing of workers.

(6 x 9 cm negative #1589)

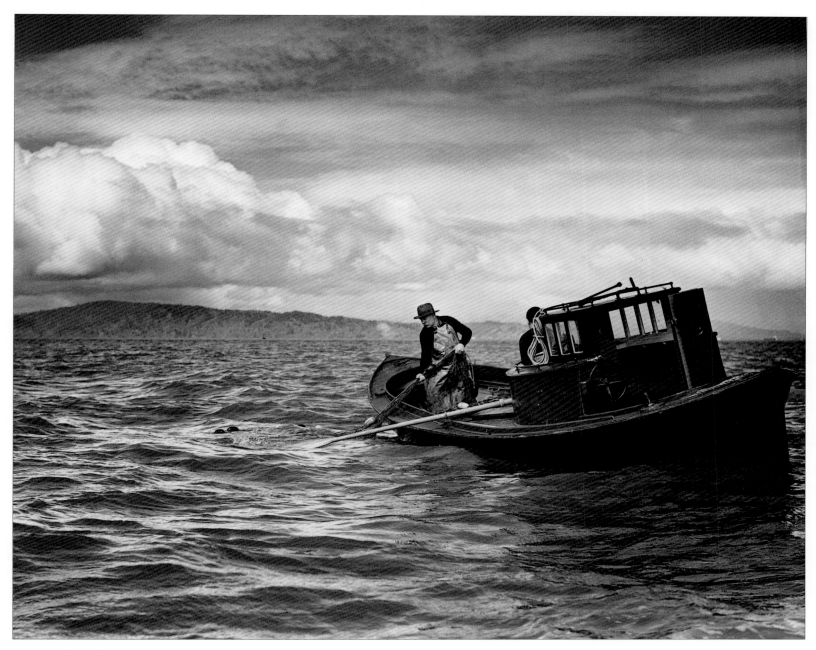

Day Fishing
1937. Ray made this image working
with a handheld 4" x 5" camera
from another boat. The choppy
waters meant that the print had
to be cropped and straightened
to correctly level the horizon.
(detail of 4" x 5" negative #1609B24)

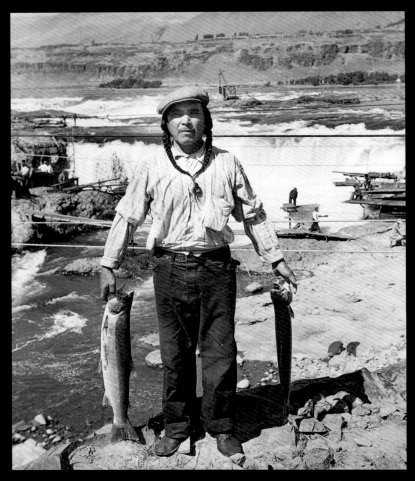

Salmon Fishing
Probably late 1930s. Jack Tuckte
stands with his catch at Celilo Falls,
an ancient Indian fishing grounds
eleven miles east of The Dalles
on the Columbia River. The falls
were submerged by the Army
Corps of Engineers when they
built The Dalles Dam in 1957.
(9 x 12 cm negative #3163A)

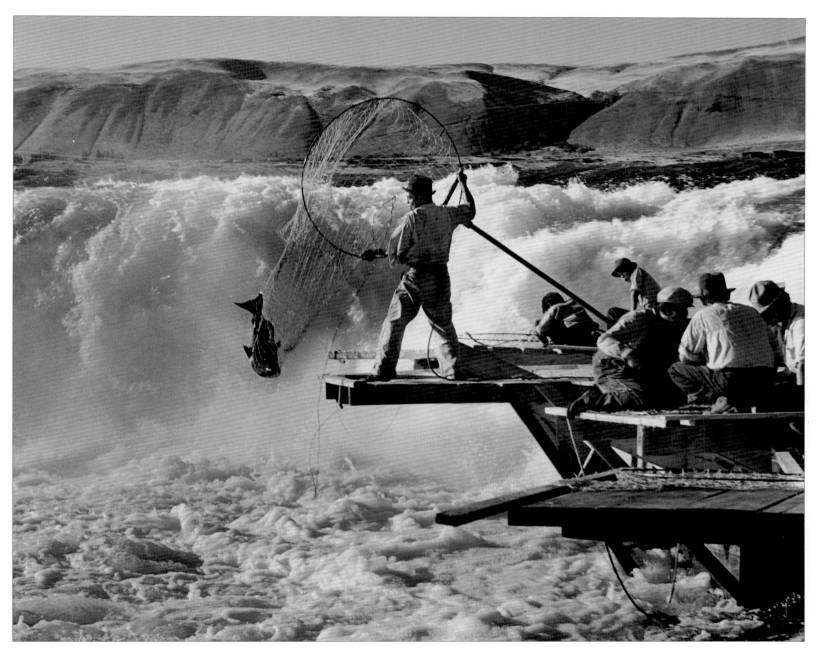

Landing a Big One
Probably late 1930s. Before Ray procured a telephoto lens, he used his large camera for a distant subject and enlarged just the center of the negative to achieve a telephoto effect, thus creating one of his most requested black-and-white photographs. The earliest known publication was in the *Kansas City Star* of August 10, 1941, where Ray wrote about the remarkable size of the salmon at Celilo Falls: "One of these Indian fishermen was observed throwing back . . . a dozen salmon nearly two feet long. He disdained them as not suitable for his purpose." (detail of 9 x 12 cm negative #3155A)

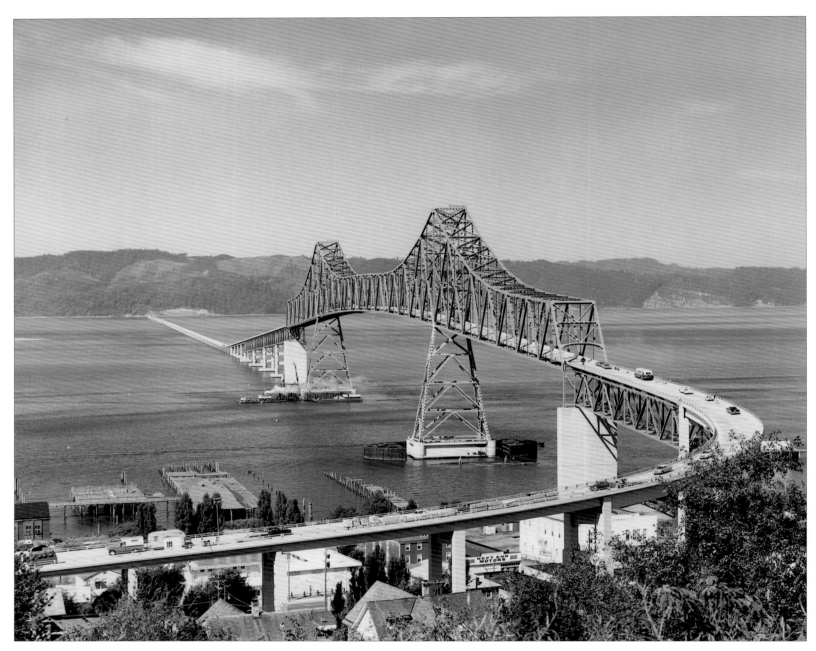

Columbia Bridge at Astoria
1964. By this time, Ray was
working almost exclusively in
color, but he also continued to
create black-and-white images.
(4" x 5" negative #8240A)

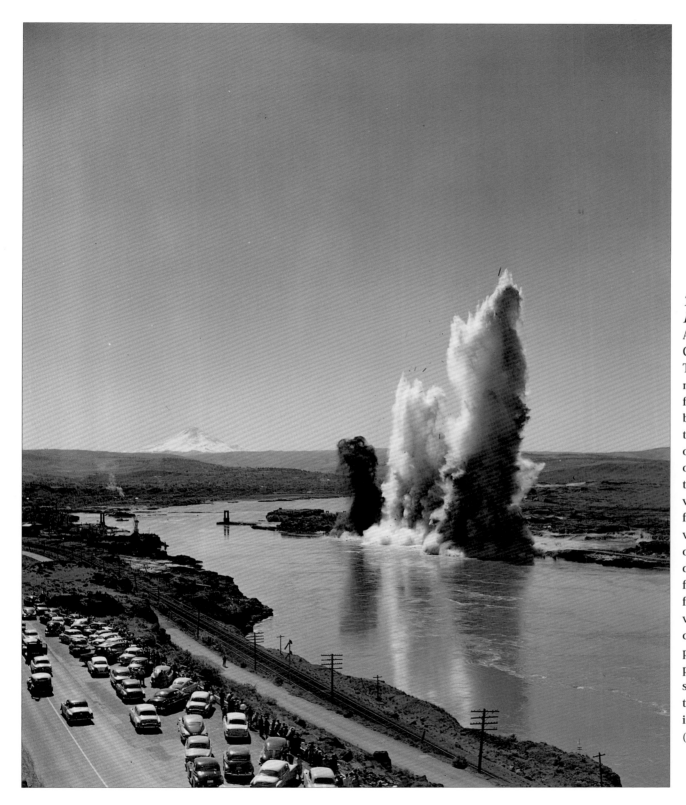

The Dalles Dam Blast
April 20, 1952. Construction of The Dalles Dam necessitated a forty-five-ton dynamite blast to dislodge sixty thousand cubic yards of basalt. Thousands of spectators lined the highway or viewed the explosion from boats. Ray wrote, "Construction of this dam will destroy the Indian fishing grounds by forming a lake which will completely cover [Celilo] falls. A picturesque and vital part of America seems to be doomed to oblivion by industrial progress."
(4" x 5" negative #6968A)

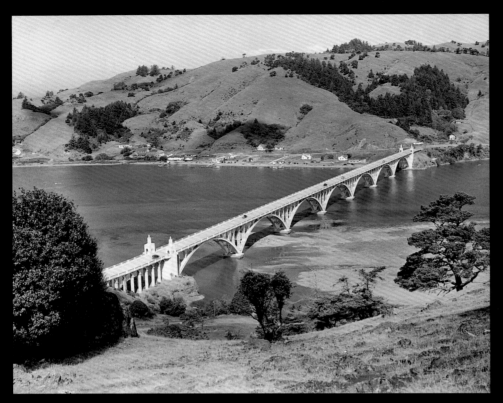

Rogue River Bridge
Circa 1930s. This photo of the
bridge over the Rogue River
was probably taken on one of
Ray's weekend jaunts. Completed
in 1932, the bridge crosses the
Rogue at Gold Beach on
Oregon Coast Highway 101.
(4" x 5" negative #3190)

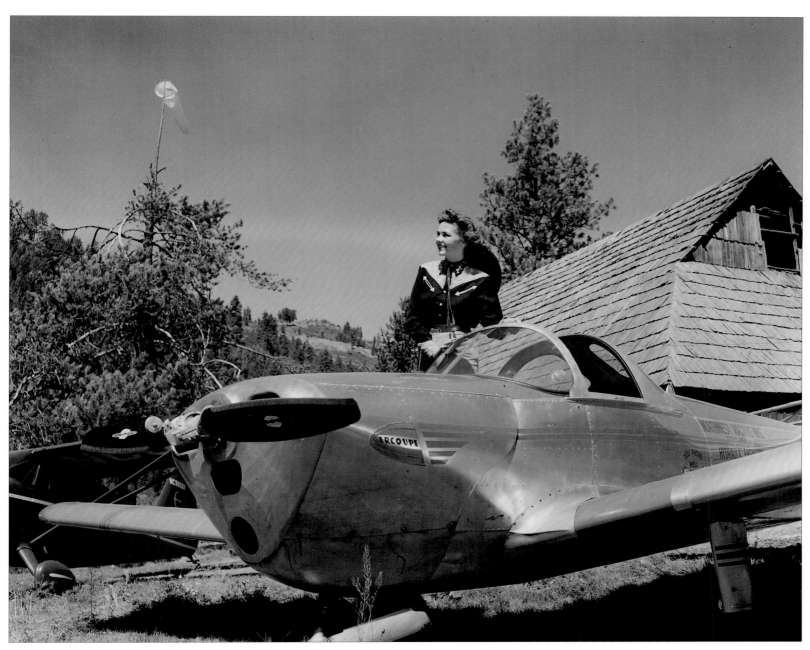

Gloria Albertson in Plane
1945. Ray photographed pilot
Gloria Albertson at Red's
Dude Ranch in the Wallowas.
(4" x 5" negative #5348)

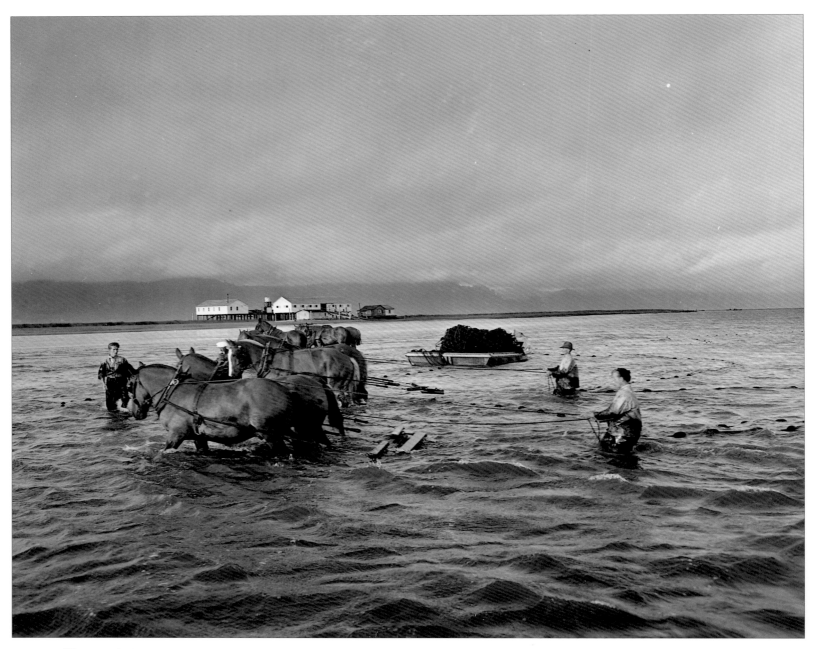

Horse-seining
1945. Columbia River Packing
Association employees used horses
to seine for salmon at Astoria.
(4" x 5" negative #4182D)

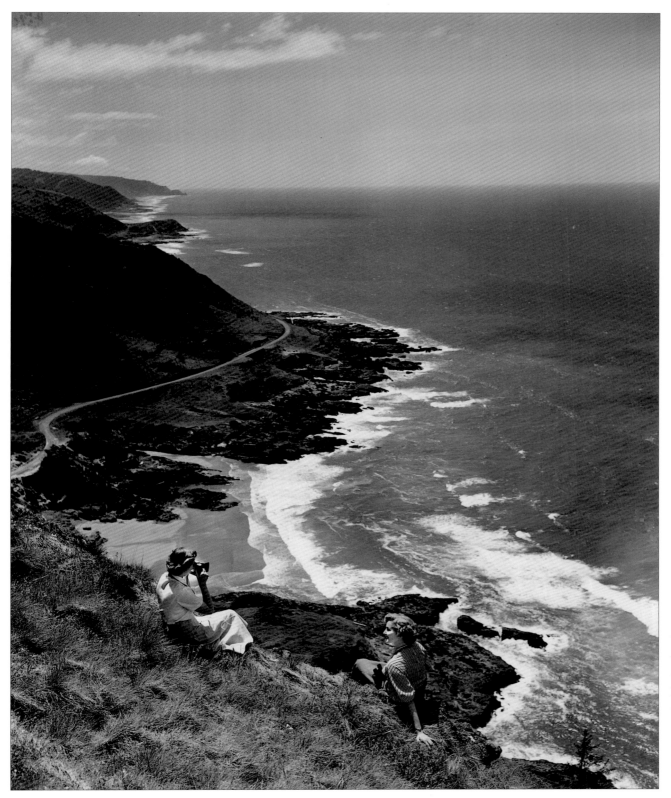

Oregon Coastline
Undated. Ray took
this view of the
Oregon coastline
looking south from
Cape Perpetua.
(4" x 5" negative #6991A)

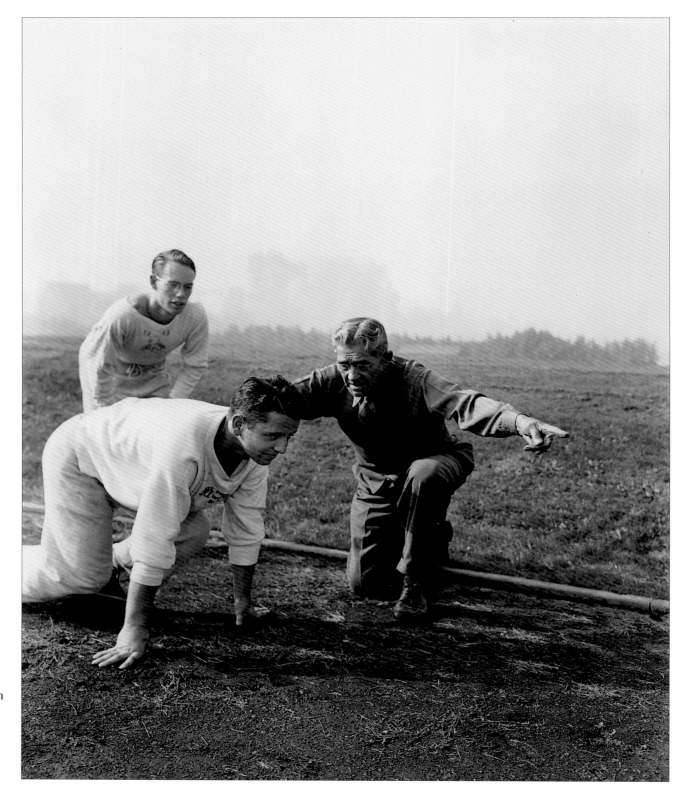

Bill Hayward
1945. In Eugene, Coach Bill Hayward worked with the University of Oregon track team.
(4" x 5" negative #4160)

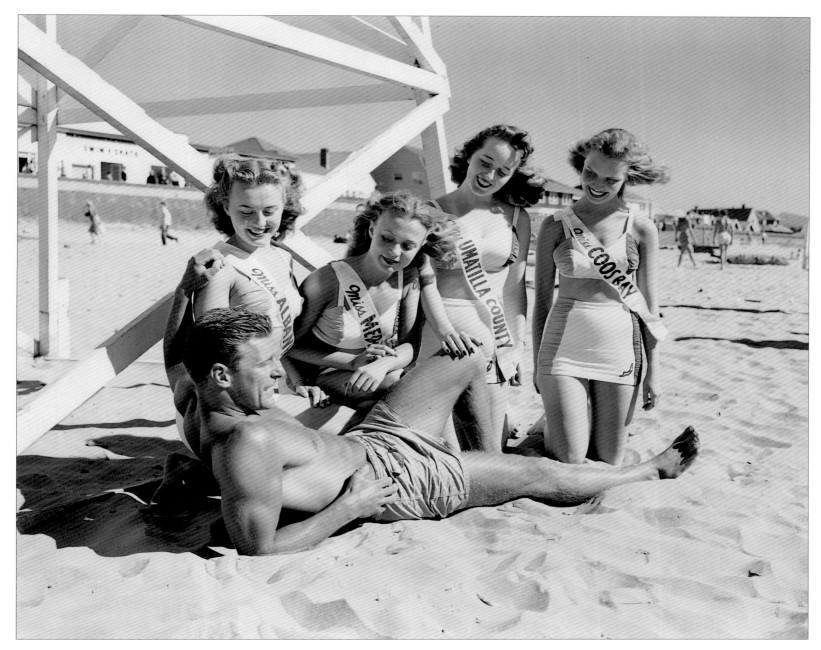

Bathing Beauties and Lifeguard
Summer 1948. Minutes after
this photo was taken at Seaside,
the lifeguard was involved in
a dramatic rescue attempt.
(4" x 5" negative #5780)

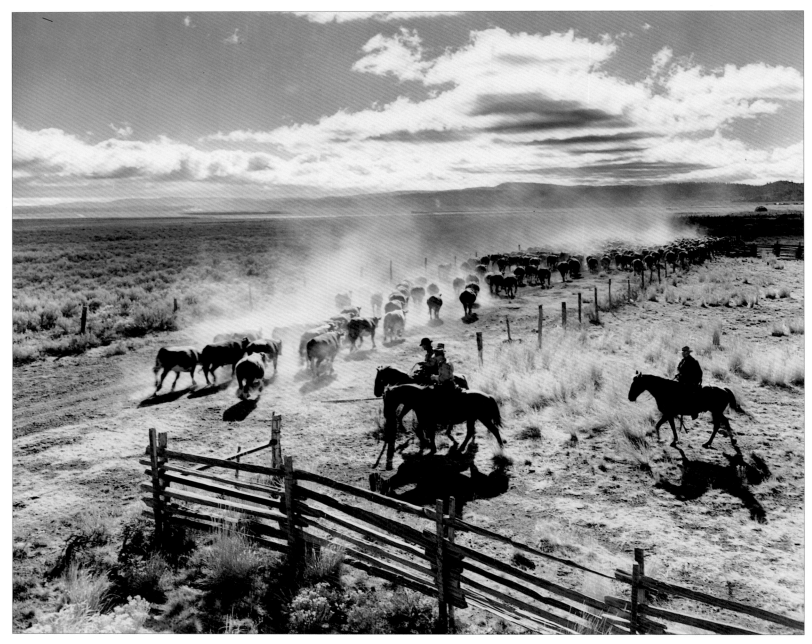

Oliver Brothers' Cattle Drive
1945. Working on assignment,
Ray photographed a cattle drive
in Seneca Valley.
(4" x 5" negative #4100)

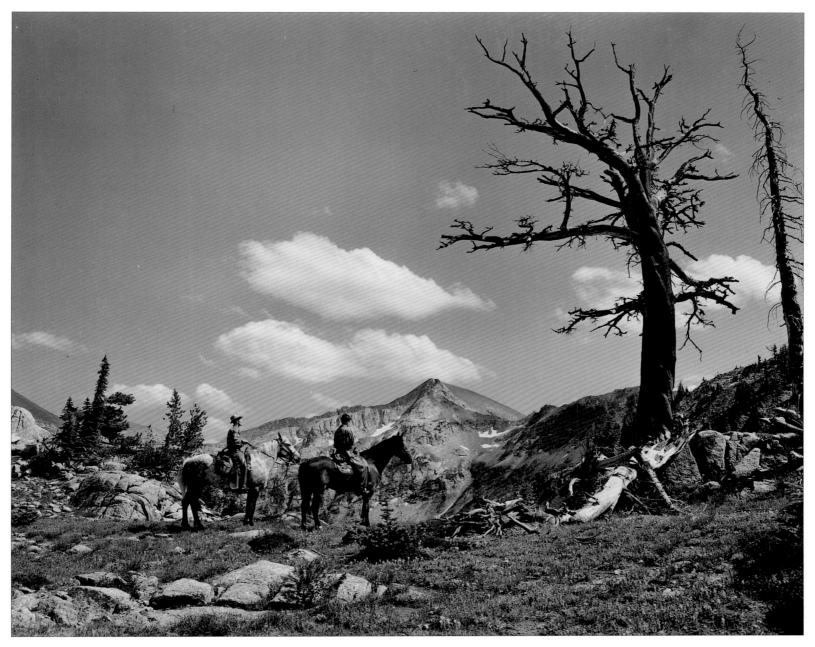

Timberline Ridge, Wallowas
1945. The two horsemen at
Timberline Ridge are so timeless
in appearance they could have
been photographed yesterday.
(4" x 5" negative #4078)

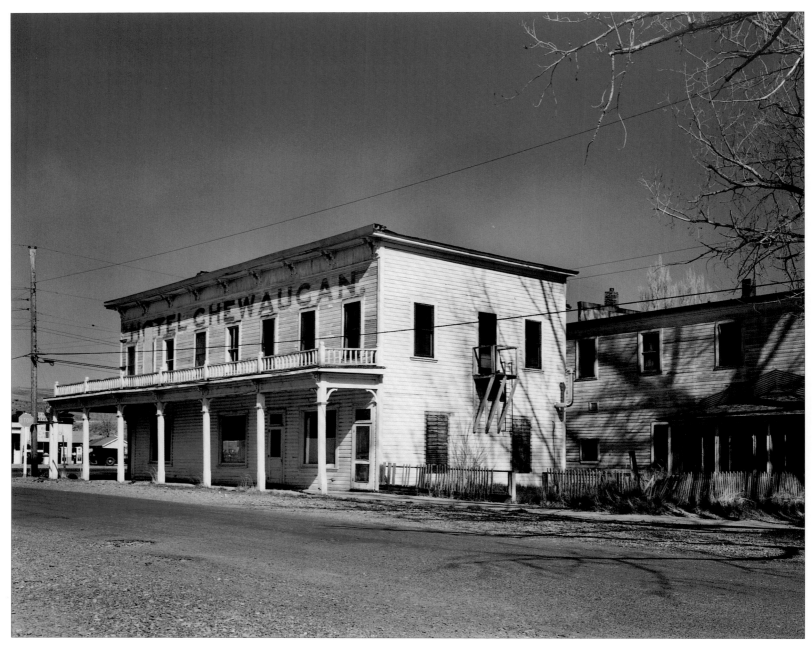

Hotel Chewaucan in Paisley
Undated. Paisley began as a
frontier town on the Chewaucan
River in central Oregon.
(4" x 5" negative #8489)

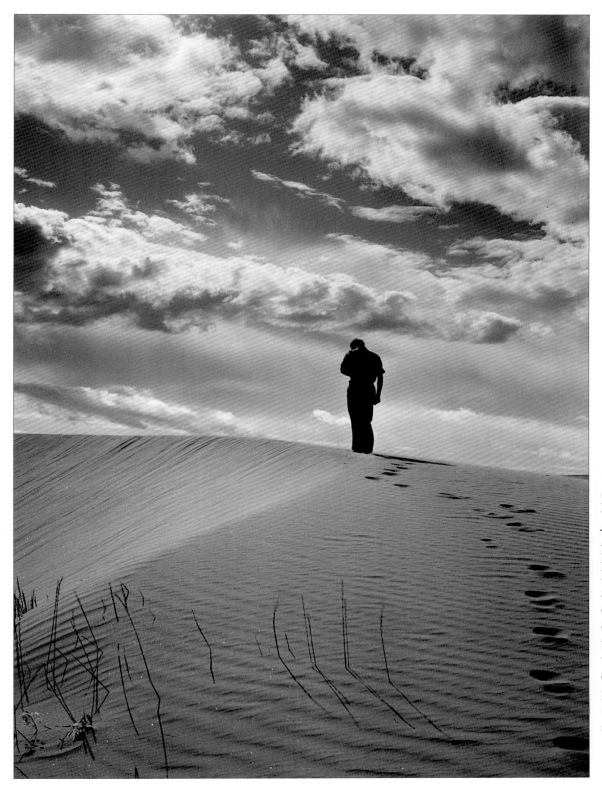

Columbia River Sand Dunes
May 30, 1932. *Oregon Journal* photographer Al Monner posed for Ray on the Columbia River Sand Dunes. Al was Ray's frequent companion on Sunday camera trips; on this Memorial Day weekend, they stayed over Monday to photograph.
(9 x 12 cm nitrate negative #698D)

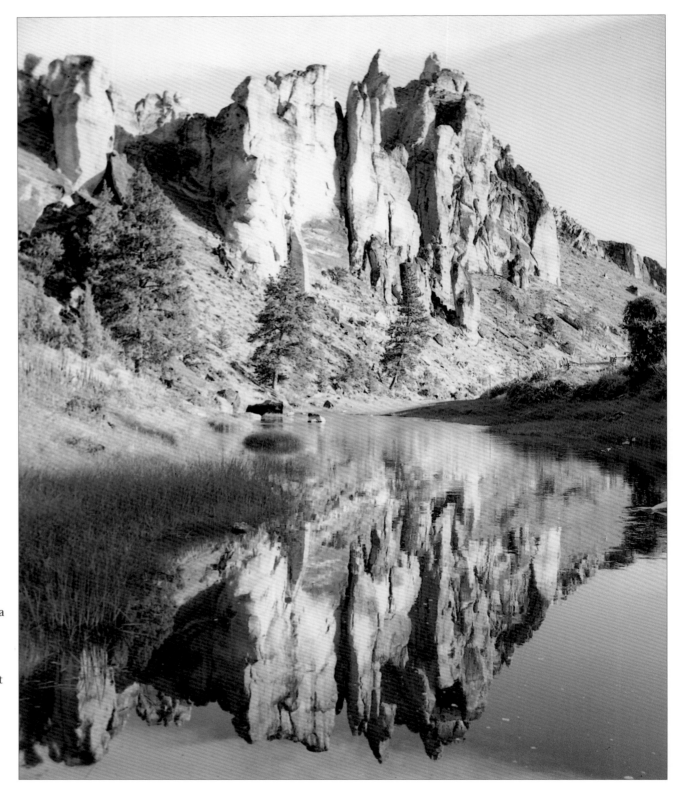

Smith Rocks and Crooked River
Circa May 1936. Ray used his Kawee folding plate camera for this image. With his typical reserve, he later described it as "a compact camera considering the size of its plates, but a rather poor lens and frustratingly frequent light leaks."
(9 x 12 cm negative #1245A)

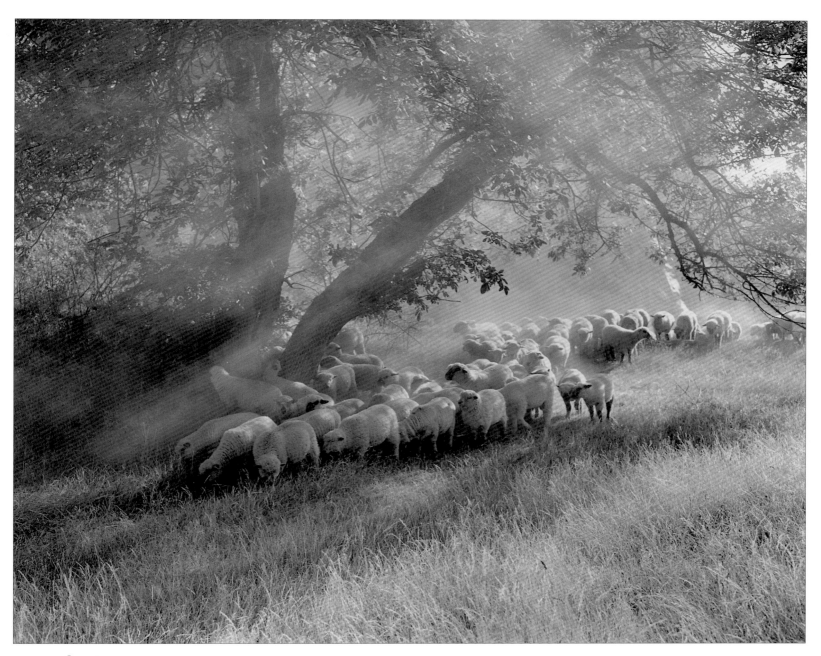

Sanctuary
Circa late 1940. A mural-sized enlargement of this photo hung in Ray's living room. "I had not yet started to think in color, but I soon would," he wrote when the image was printed in his book, *Western Images*. The photograph was taken in an area now part of Rooster Rock State Park. The first known publication was in a photography magazine of December 1942. (4" x 5" negative #3151A)

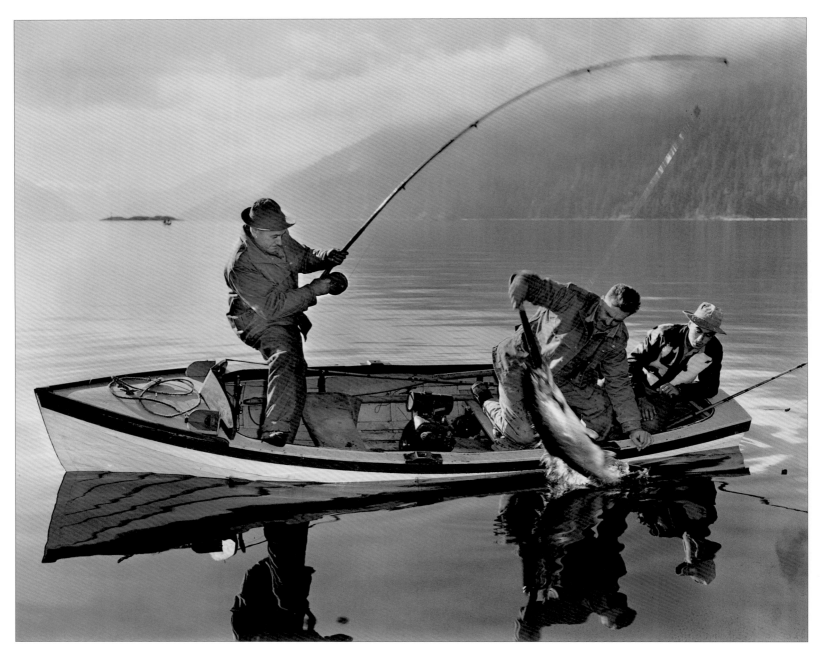

Catching Salmon
Circa 1948. Andy Thomas
and fellow fishermen
apparently had a lucky day.
(4" x 5" negative #5838A)

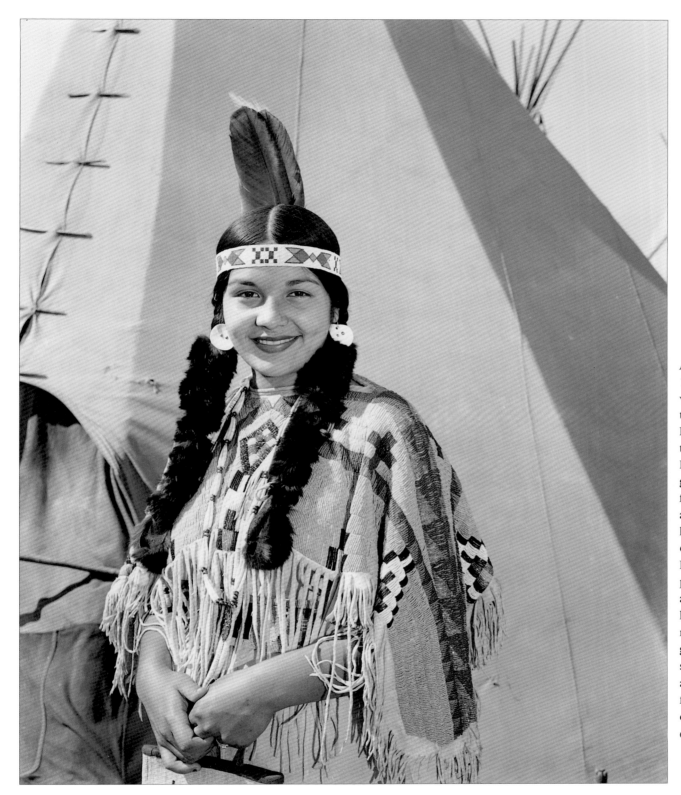

Dolores Stevens
1945. Miss Stevens was the winner of the American Indian Beauty Contest at the 1944 Pendleton Round-Up. Ray photographed her in color for his photo essay about Oregon published by *National Geographic* in 1946. Ray was skilled at portraiture, blending a "fill flash" bulb on his camera with the natural sunlight to give detail in the shadows, which was absolutely necessary for color shots on early Kodachrome.
(4" x 5" negative #4092B)

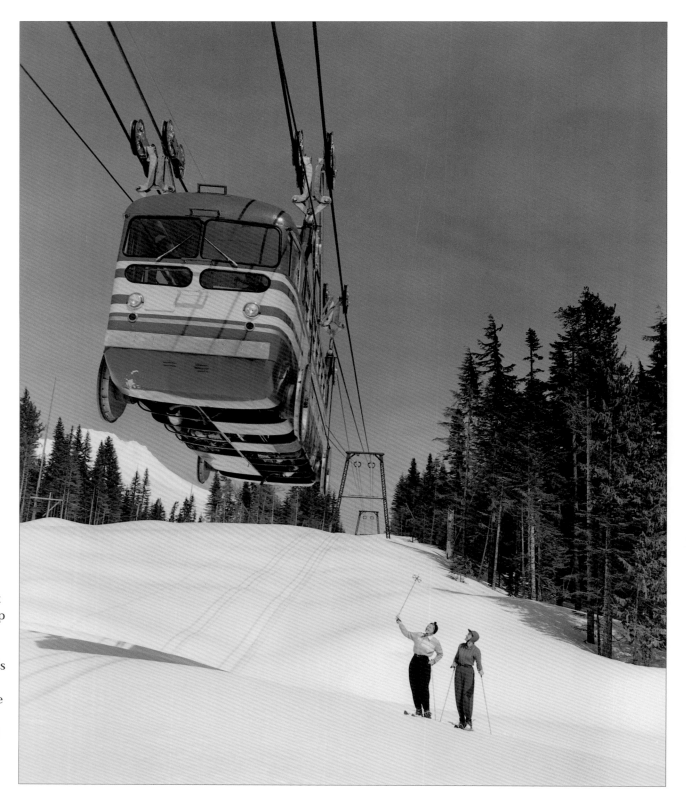

Ski-way
Circa 1950. The skyhook design of the locally built cars was borrowed from the logging industry. Ski-way carried passengers from a terminal west of Government Camp to a landing one hundred yards west of Timberline Lodge's main entrance. The cars and towers were removed in 1956.
(4" x 5" negative #6398A)

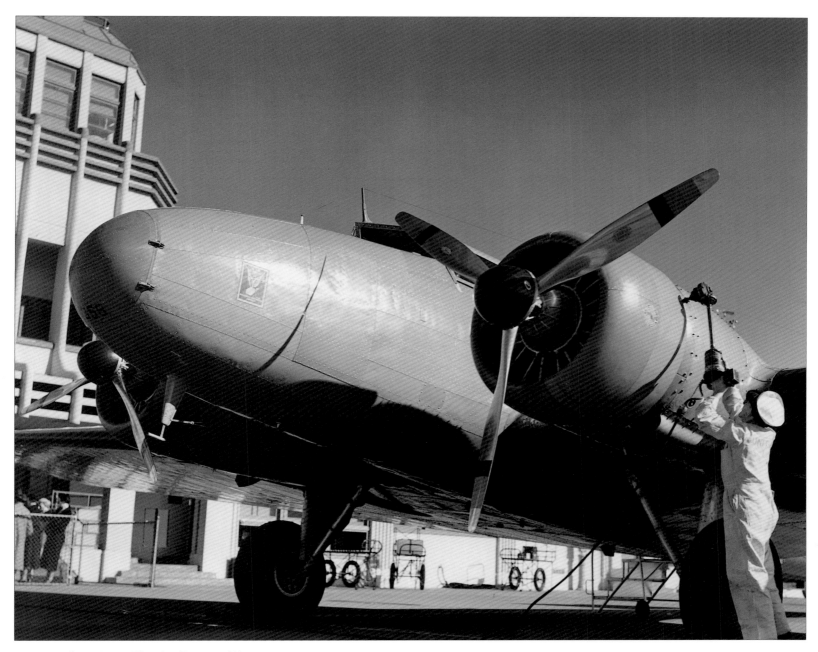

Cranking Up the Boeing Plane
Late 1936. Portland's original
airport was located on Swan Island.
(4" x 5" negative #1416)

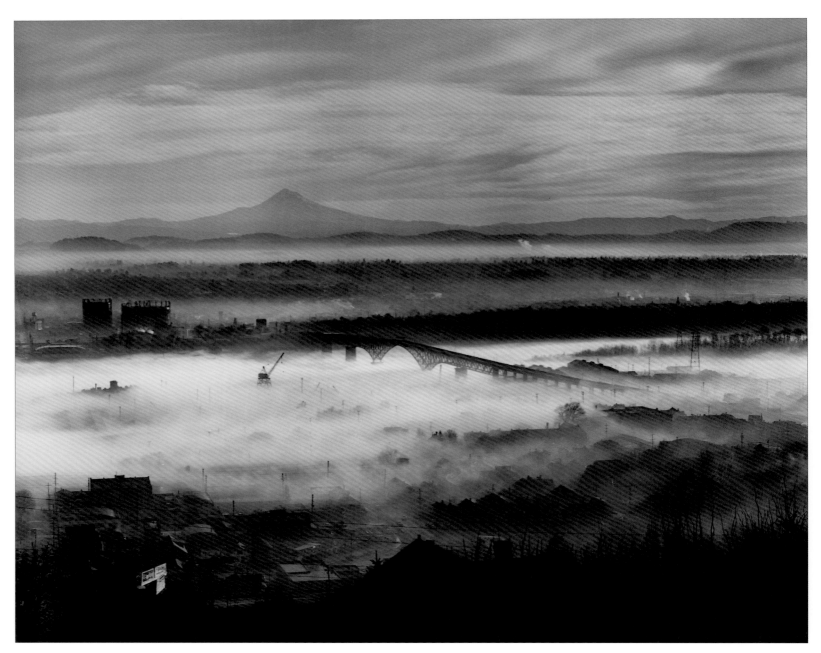

Portland with Mount Hood
Circa 1955. Portland's Ross Island Bridge
spans the fog-shrouded Willamette River.
(4" x 5" negative #7573C-2)

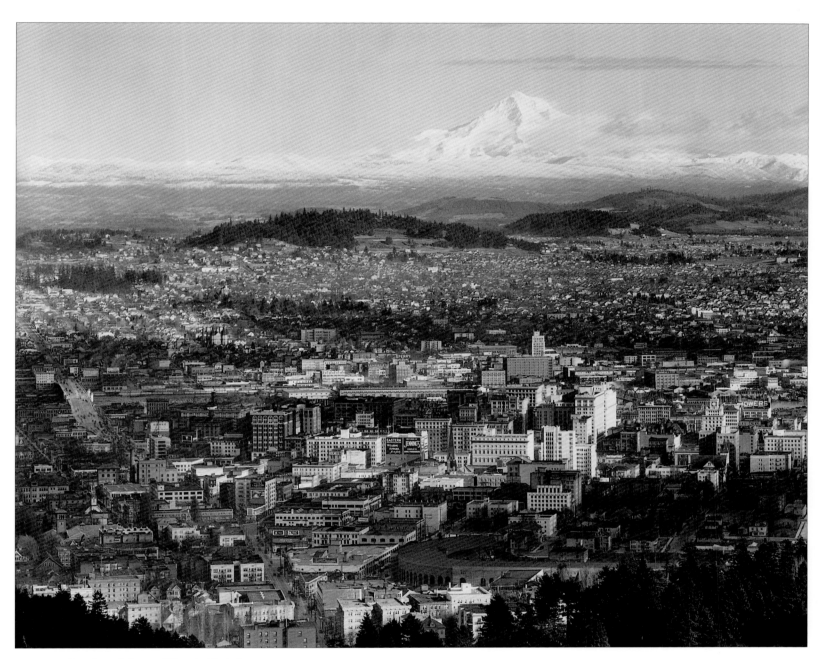

Portland from King's Heights
Circa 1930. Portland seemed to
stretch almost to Mount Hood in
this bird's-eye view from King's
Heights, published by *National
Geographic* in February 1934.
(5" x 7" nitrate negative #S25C)

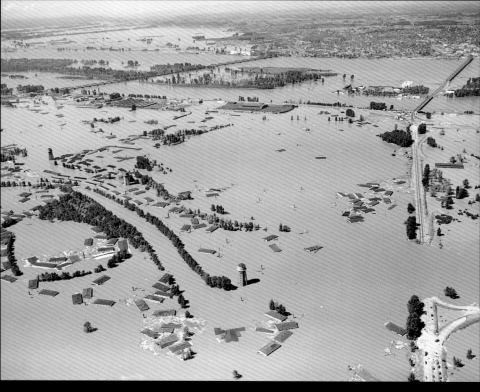

Vanport Flood
1948. The flood of May 30, 1948,
wiped out Oregon's second-largest
city. Photographed the following day,
the view looking north shows Denver
Avenue and the Interstate Bridge
across the Columbia on the right; the
railroad bridge is on the left.
(4" x 5" negative #5667C)

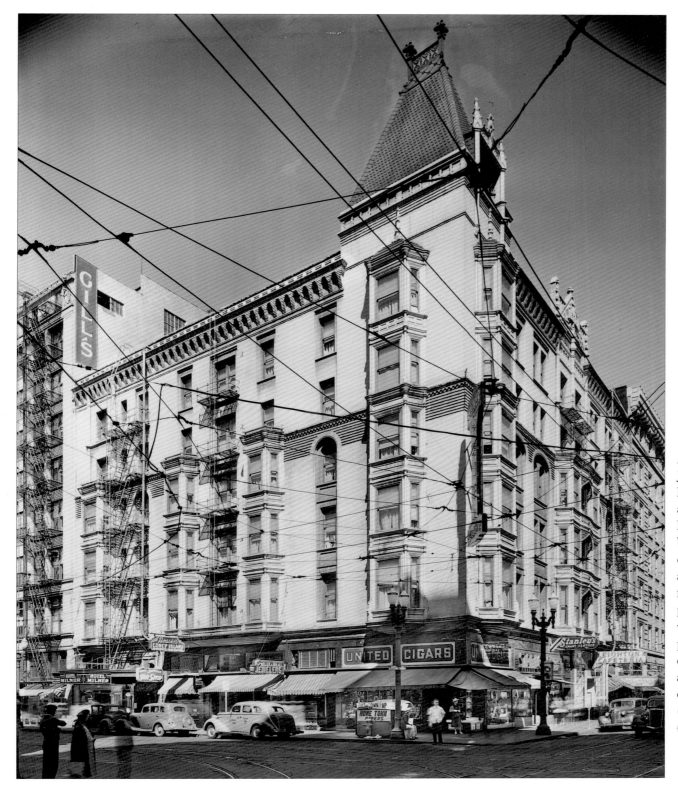

Milner Hotel
July 8, 1939. The Milner Hotel, located at 422 Southwest Fifth Avenue near Washington Street, commissioned an advertising illustration from Photo Art. Before printing engravings were made from Ray's photo, a staff artist expertly airbrushed all the trolley wires out of the image.
(8" x 10" negatives #PA26052A)

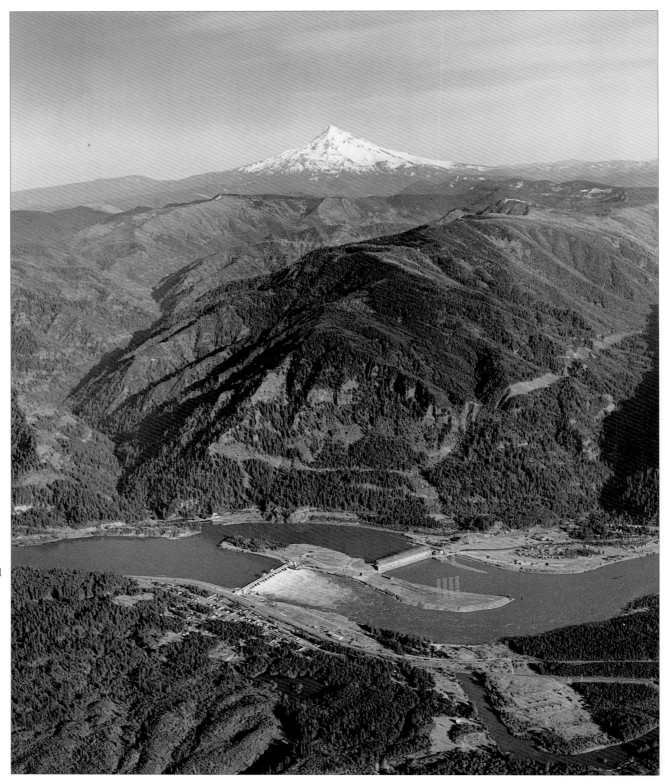

Bonneville Dam and Mount Hood Circa 1946. In a 1970 interview, Ray reported to the *Oregonian* that "in the old days one could be sure to have twelve crystal clear days a year, but today we can consider ourselves lucky to have one or two days." (4" x 5" negative #4357A)

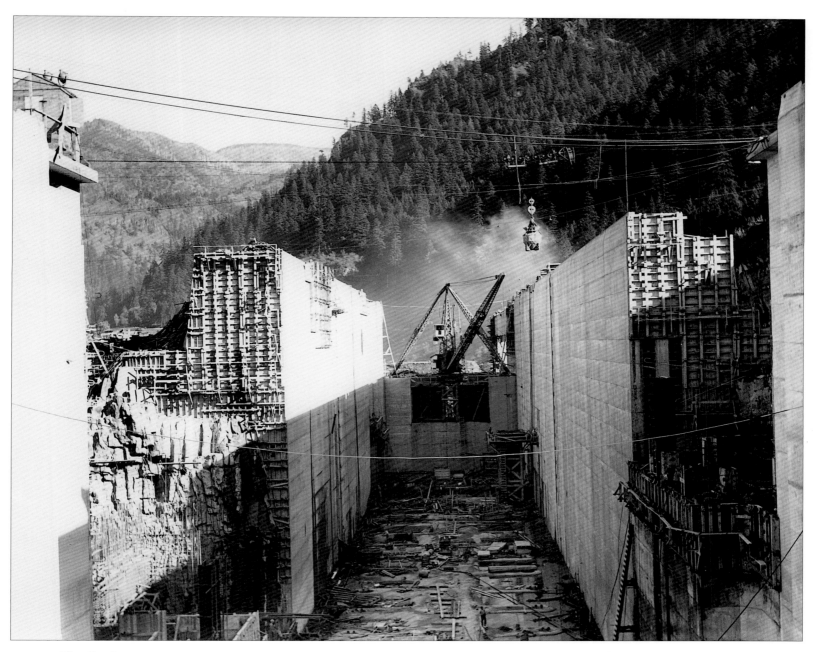

The Locks
1935. Ray photographed the Bonneville
Dam during construction, which began
in 1933, and returned to photograph
President Franklin Roosevelt when he
dedicated the dam in 1938.

(4" x 5" nitrate negative #1035)

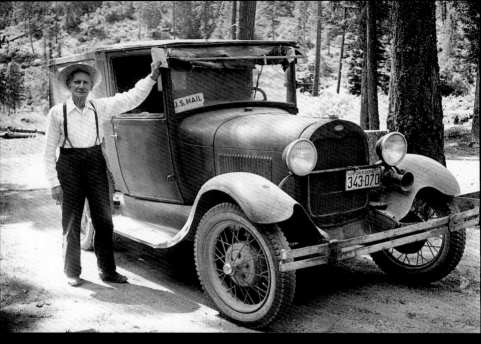

The Mailman
Summer 1952. An elderly mail carrier
and his antiquated vehicle provided
postal service in Eastern Oregon. He
seems to have had enough confidence
in his trusty car to buy new 1953
license plates for it well in advance.

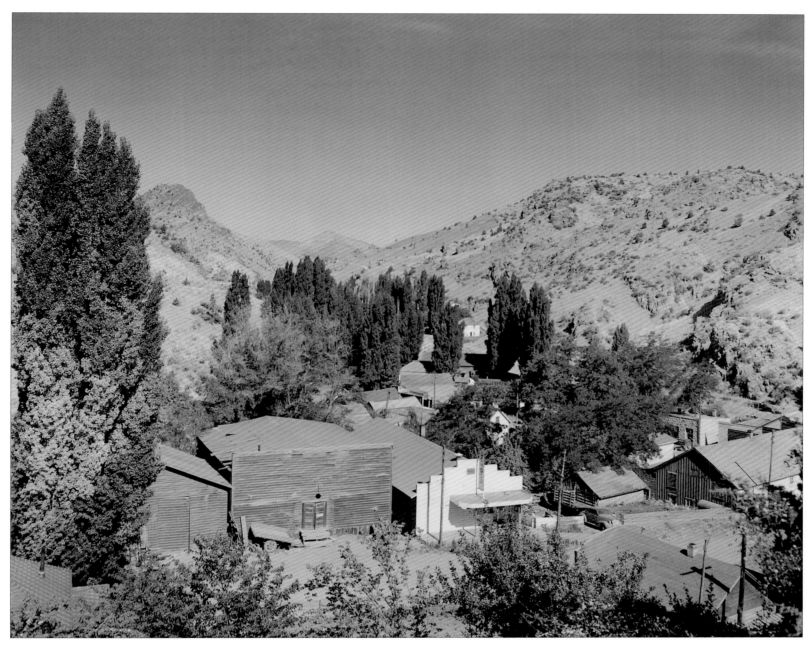

Mitchell, Oregon
June 1949. Burned out, washed out, and—
at various times—besieged by desperadoes,
Mitchell was established in 1867 as a stage
station on The Dalles–Canyon City route.
(4" x 5" negative #6190)

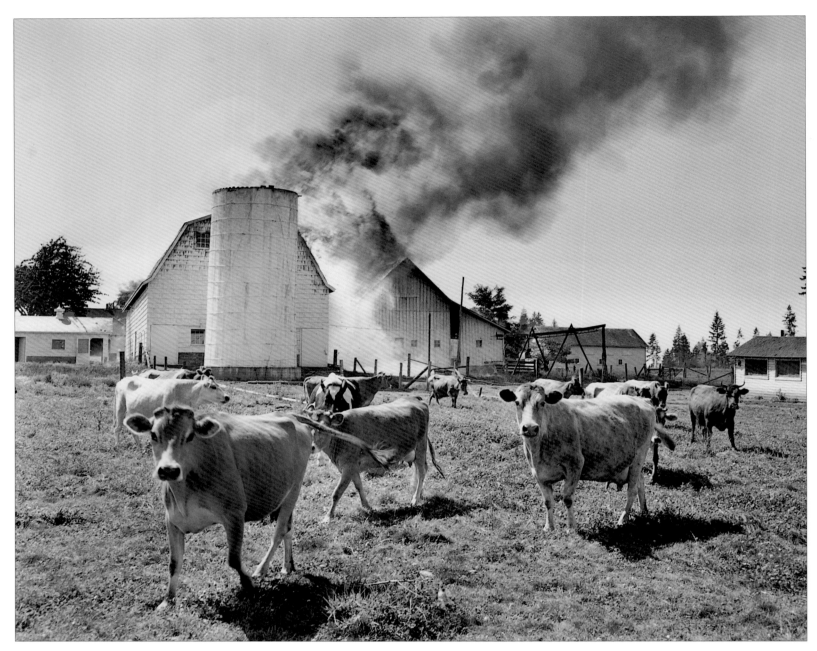

Burning Dairy Farm

1947. Mira occasionally wrote articles for photography magazines, and in one she explained how Ray reacted when he saw a fleeting moment he wanted to photograph: "Hand me the camera quick and get the yellow filter out of the case." Family legend says that Ray was driving home from a rural assignment when he saw this conflagration. The negative is surrounded in his file system by pictures of many dairy farms in central Oregon, probably resulting from an unrecorded assignment. (4" x 5" negative #5278B)

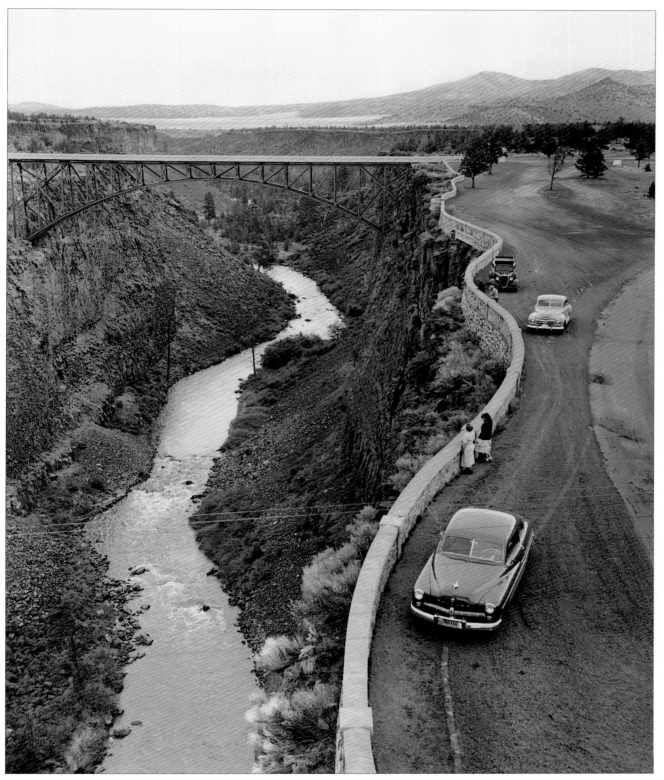

***Crooked River
and Park***
Circa 1951. Ray
apparently climbed
up on a nearby
railroad trestle for
this image.
(4" x 5" negative #6066)

Saturday Evening Post
1951. Author Richard Neuberger (standing) and a group of students were photographed for the *Saturday Evening Post*. One of Oregon's best-loved writers, Neuberger collaborated with Ray on a number of projects.
(4" x 5" negative #6585-14)

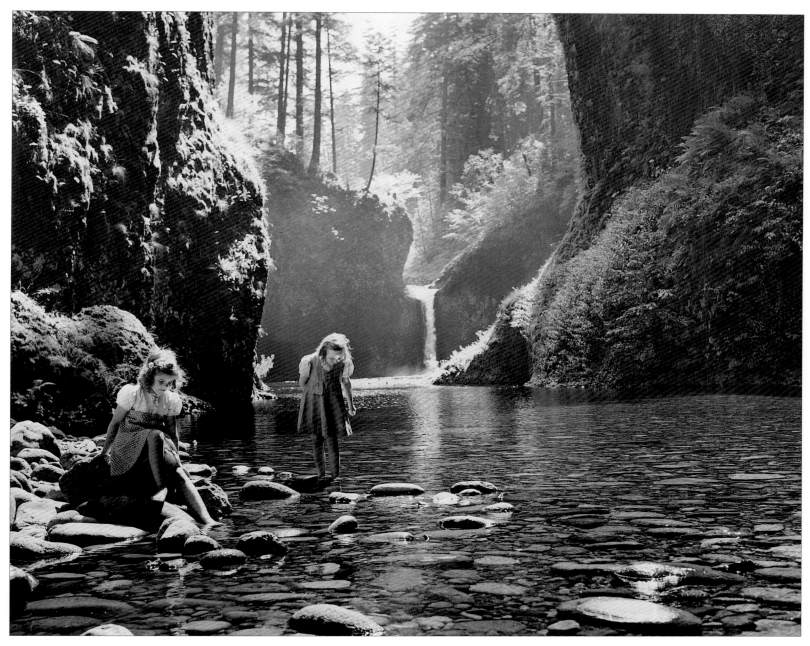

Eagle Creek Punchbowl
Early 1940s. On weekends, when Ray was able to
photograph what and where he chose, he often
chose pristine locations such as this. Eagle Creek
Punchbowl is located in the Columbia River
Gorge, a comparatively short drive from Portland.
(Vintage silver gelatin print from lost negative #3466B)

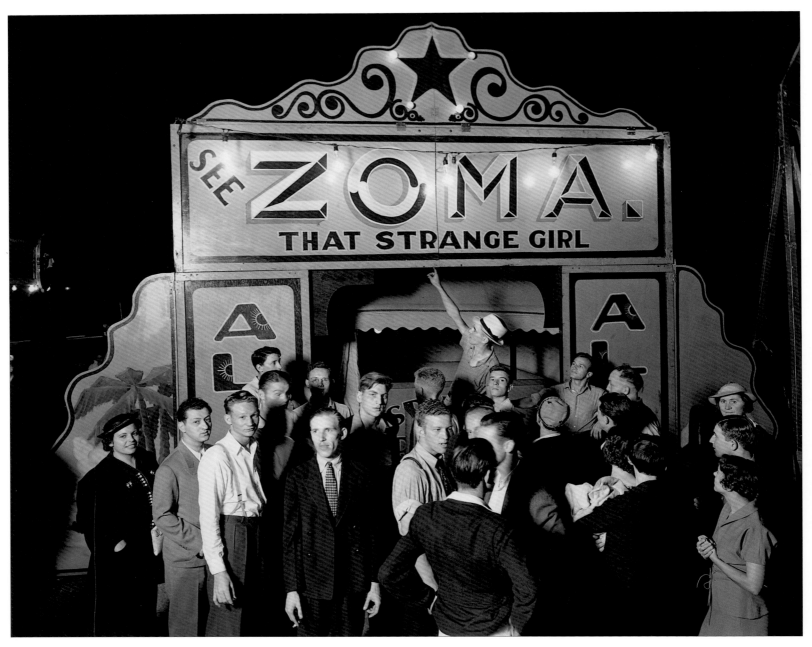

Ziegler Shows, Portland
July 1937. Ziegler Shows
was a traveling carnival that
"worked" Portland's Fleet
Week. After World War II,
Fleet Week was combined
with the Rose Festival.
(8" x 10" negative #PA14656D)

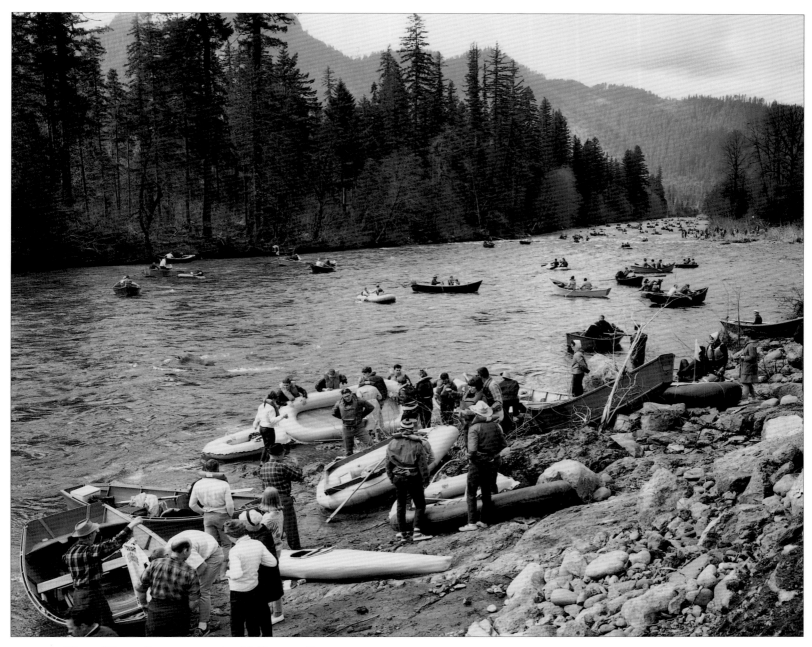

White Water Parade on the McKenzie River

Circa 1950. Ray joined those opposing a dam construction project on the McKenzie River. Local power companies had already received a federal license under the misleading name of the "Beaver Marsh Project." Richard Neuberger, after winning a seat in the 1954 U.S. Senate, became a one-man environmental movement until his untimely death from cancer in 1960. He introduced a bill revoking the permit, and Ray went to work organizing conservationists, who successfully stalled the project. (4" x 5" negative #8108A)

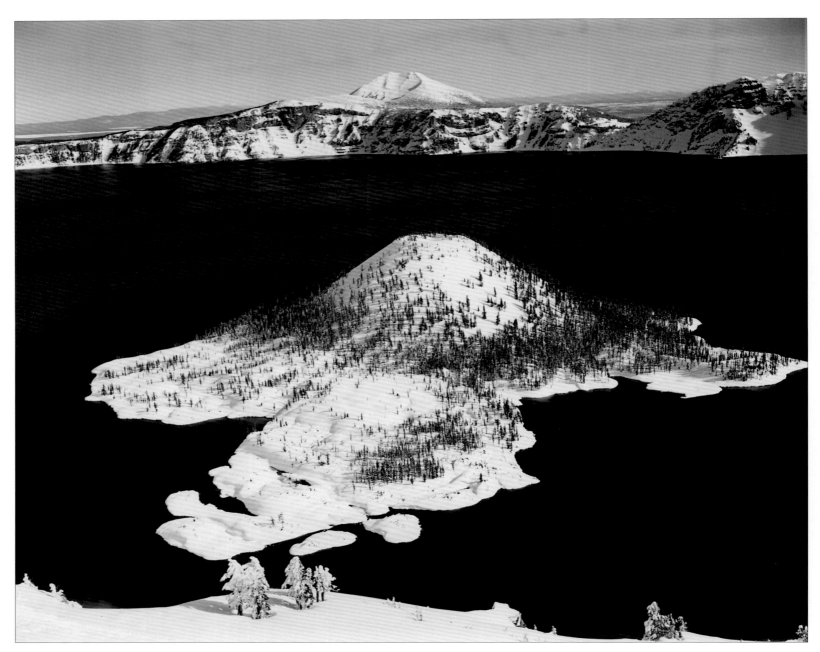

Crater Lake

January 1941. Sometimes getting the image he wanted posed unexpected hazards. Ray wrote, "A park ranger accompanied me on a wonderful ski tour around the rim of the lake for several miles. To get an unobstructed view, the ranger held on to my belt with one hand and a tree limb with the other hand." Ray photographed the scene in both color and black and white. This image was first published in the March 9, 1941, *Oregon Journal*. The color shot appeared in *National Geographic.* (4" x 5" negative #3245A)

Trees at Crater Lake Lodge
January 1941. Newspapers in the East published photos of these snow-laden trees, giving a boost to both Ray's and Oregon's popularity.
(4" x 5" negative #3279A)

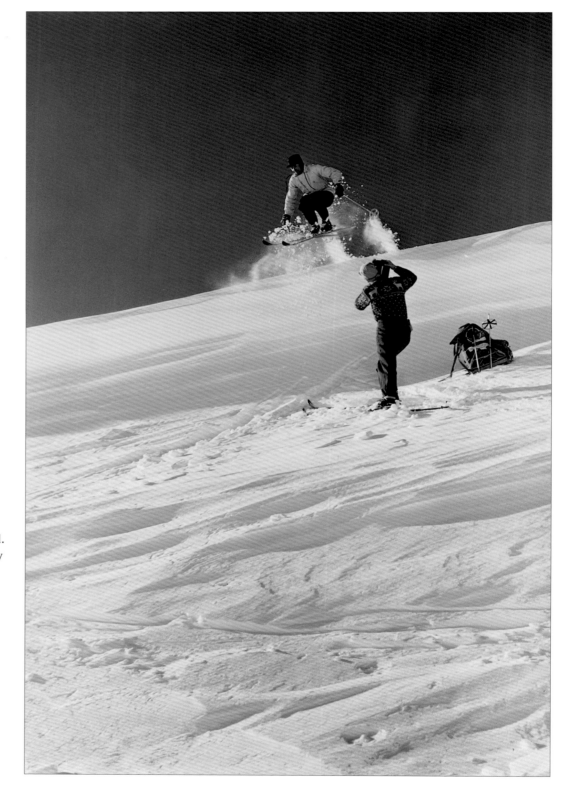

Ray and Olaf
Circa 1945. Mira Atkeson took this photograph of Ray photographing his friend Olaf Rodegard. Ray wrote, "Probably no other skier has flashed before my camera as many times as has Olaf, and few have been so cooperative, patient, hard working, and daring." (6 x 9 cm negative #4586C)

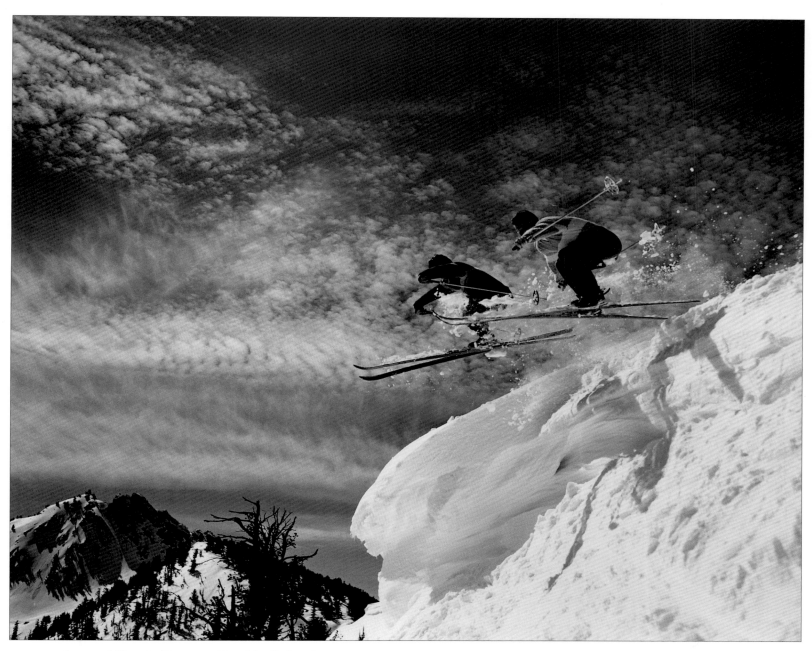

Art and Howie Doing a Double Geländesprung
Circa 1948. Champion skier Olaf Rodegard, who
owned the resort at Anthony Lakes for several
years, identified this picture in 1997. Photographer
Hugh Ackroyd, on reviewing these photographs in
1990, commented that Ray's "timing had to be
beyond belief." (4" x 5" negative #5620)

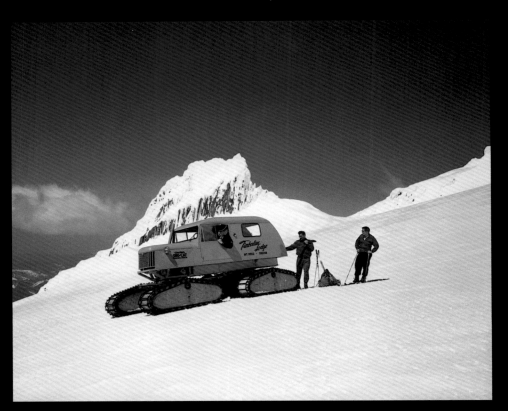

Snow Cat and Illumination Rock
Circa early 1950s. Throughout the
1950s, brothers Lew and Scott Russell
volunteered to pack and groom the
lower reaches of Glade Trail with their
Tucker Snow Cat. Their efforts greatly
reduced accidents, and they were
made honorary members of the Mount
Hood Ski Patrol. (4" x 5" negative #7454A)

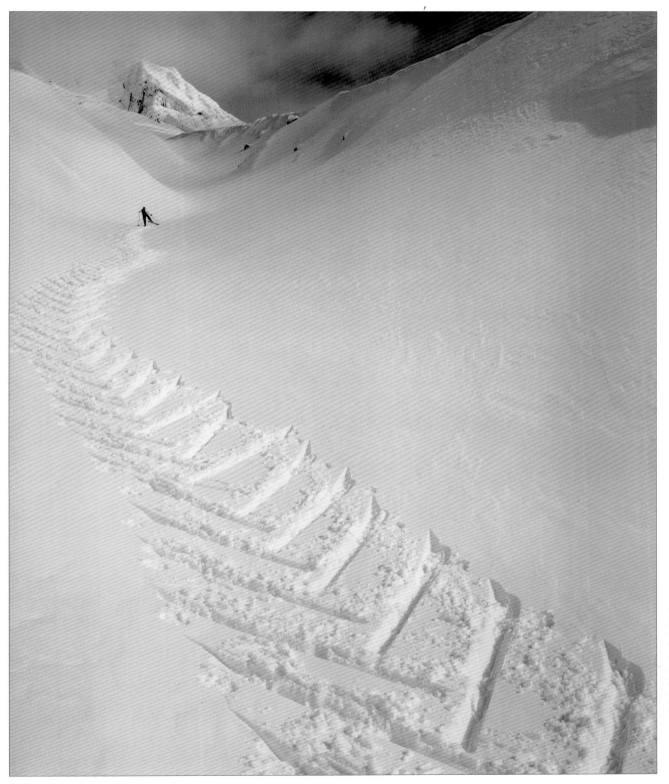

Herringbone Tracks
Circa 1940.
Herringbone tracks
created an interesting
pattern at Salmon
River Canyon on
Mount Hood.
(4" x 5" negative #2973A)

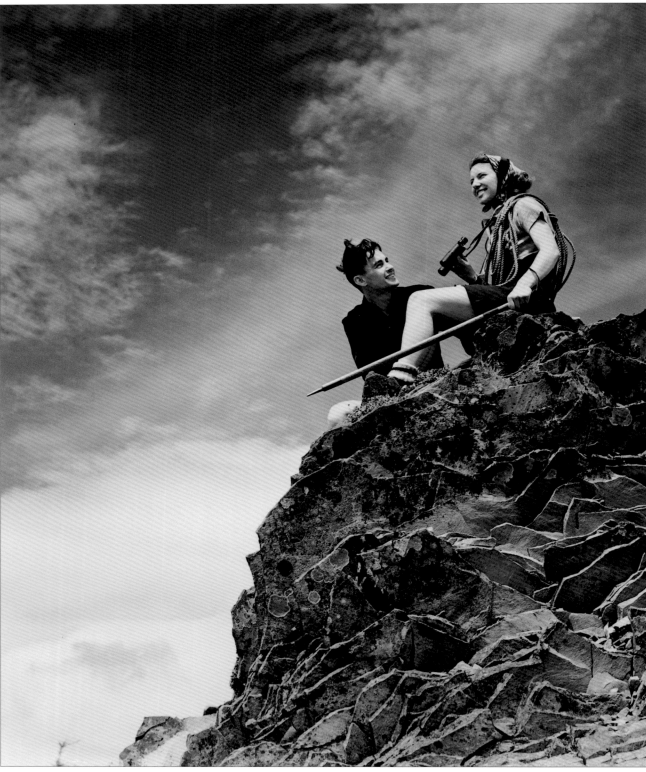

High Rocks
Circa late 1930s.
Climbers rest atop
practice rocks
in the Columbia
River Gorge near
Bridal Veil.
(4" x 5" negative #2261A)

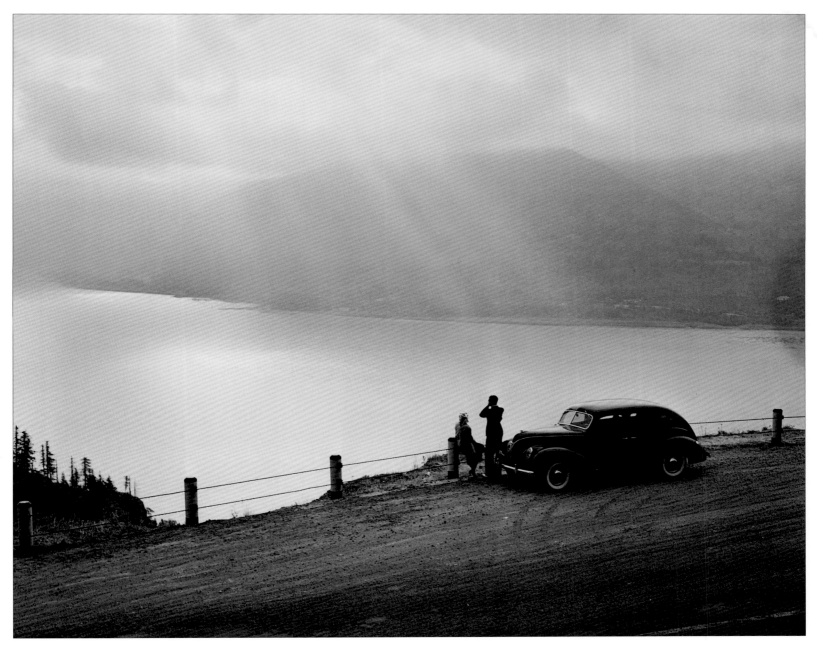

Columbia River from Cape Horn
Circa late 1930s. Cape Horn, on the
Washington side of the Columbia
River, was the vantage point for this
foggy view south into Oregon.
(4" x 5" negative #2322A)

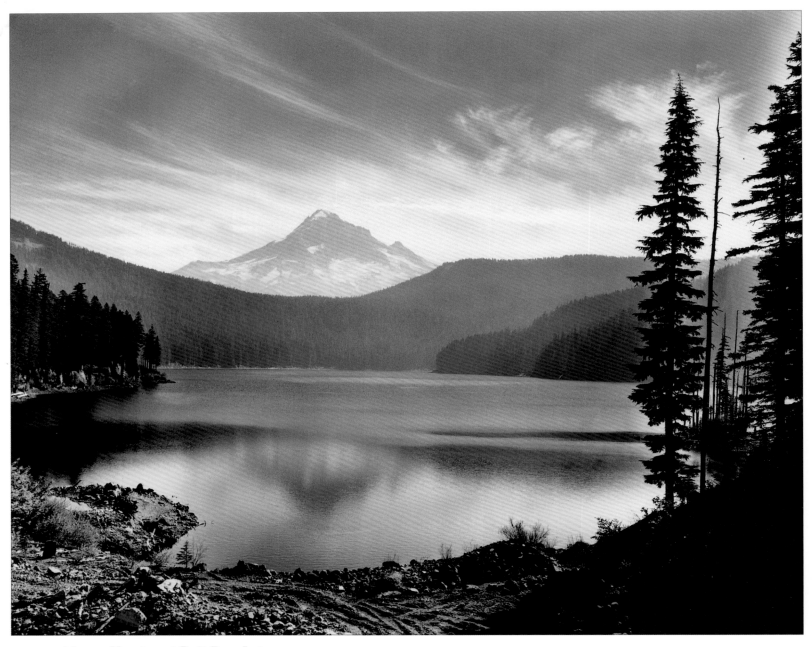

Mount Hood and Bull Run Lake
Undated. Bull Run Lake is the source of
Portland's water supply. Photographer
Charles Talbot, who long predated Ray,
secured the watershed for the city. The
Talbot family emigrated to Oregon in
1849, settling the land now known as
Council Crest. (4" x 5" negative #7639B)

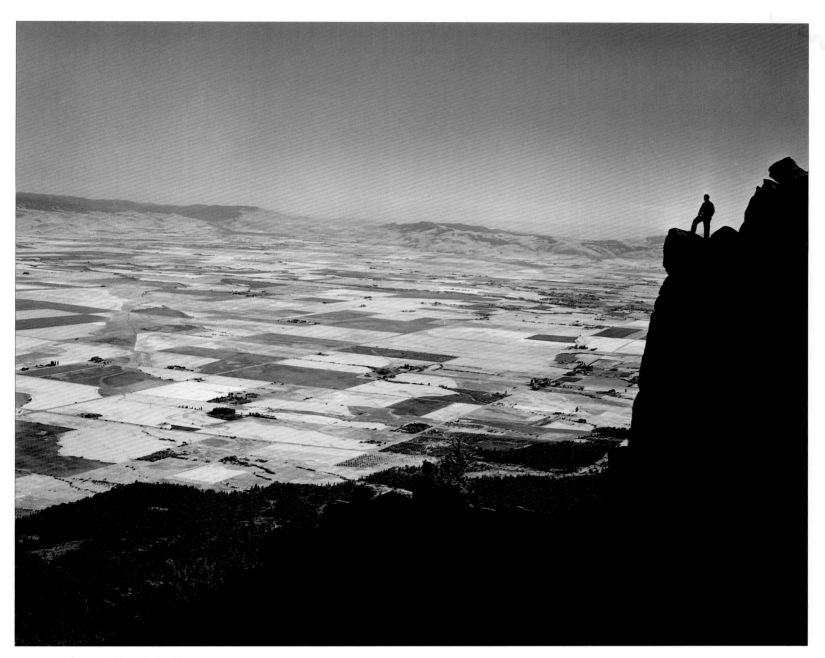

Grand Ronde Valley
Circa early 1940s. This "patchwork"
view of farms in the Grand Ronde Valley
was taken from nearby Mount Emily.
(4" x 5" negative #4082)

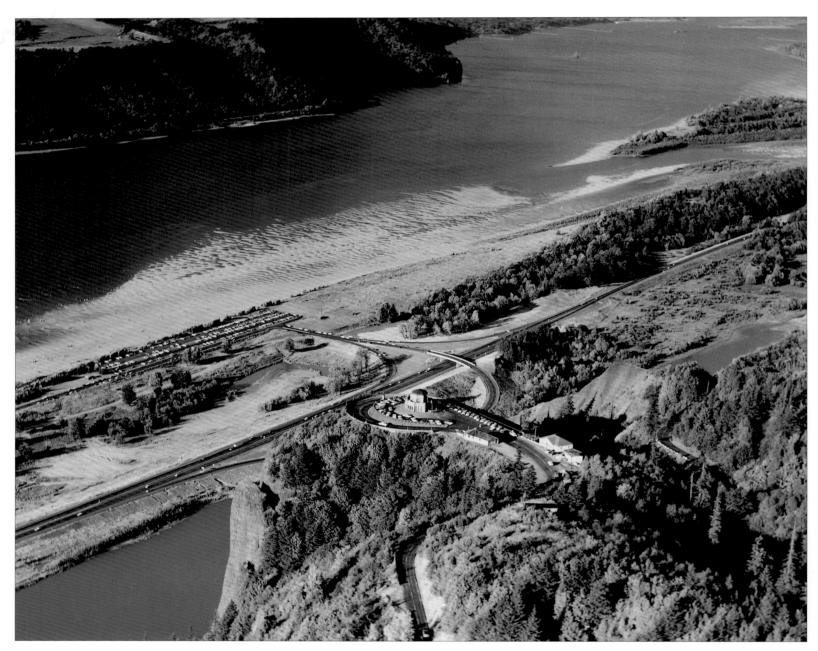

Crown Point from the Air
Circa late 1950s. Vista
House looks out over the
Columbia River Gorge from
its perch atop Crown Point,
725 feet above the river.
(4" x 5" negative #7584A)

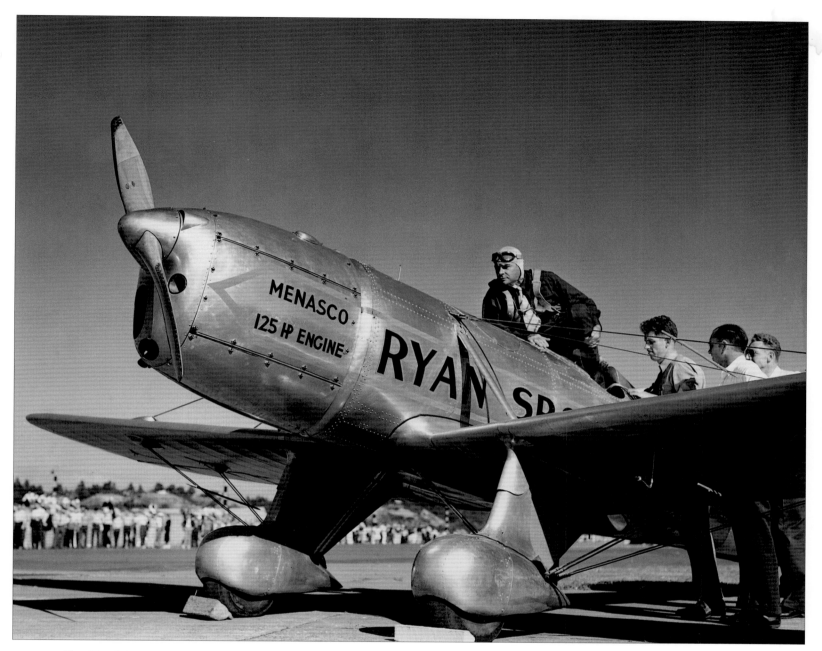

Tex Rankin
1937. Tex Rankin, who ran an aerial circus based
on Swan Island, won the world championship
for aerobatics in 1937. His Hollywood credits
included stunt flying in the Clark Gable film
Test Pilot, as well as *Wings, Hell's Angels,* and
Flying Leathernecks. (4" x 5" negative #1797)

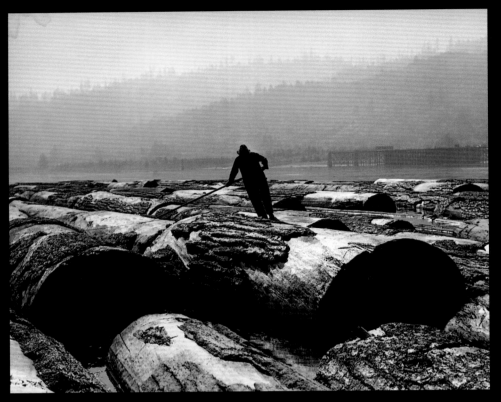

Huge Logs in W. C. P. Raft, St. Johns
1936. Ray frequently photographed various
aspects of one of Oregon's major industries—
logging. Over the years, only the size of the
logs changed. (4" x 5" negative #1375B)

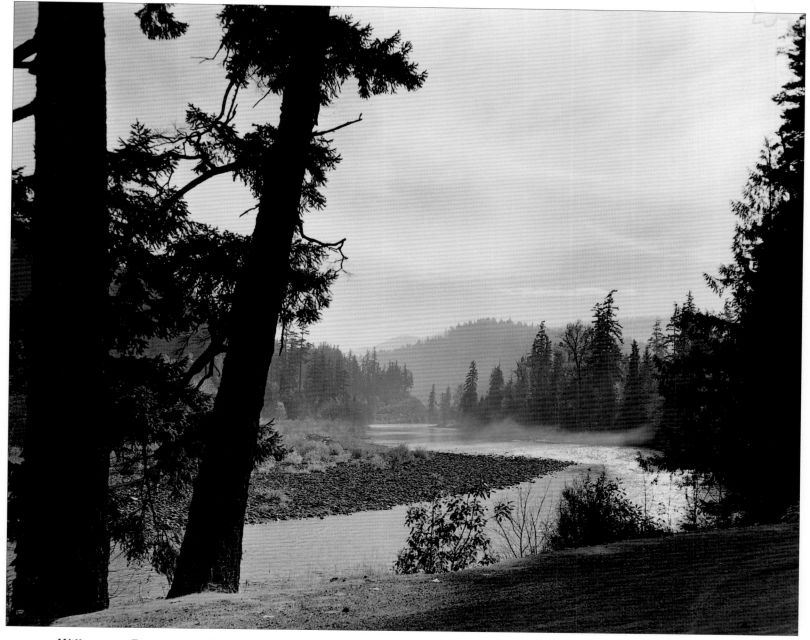

Willamette River near Oakridge
1948. Now a freelancer, Ray was
free to take photographs anywhere
he chose—and he frequently aimed
his cameras at idyllic scenic views
of his beloved Oregon countryside.
(4" x 5" negative #5851B)

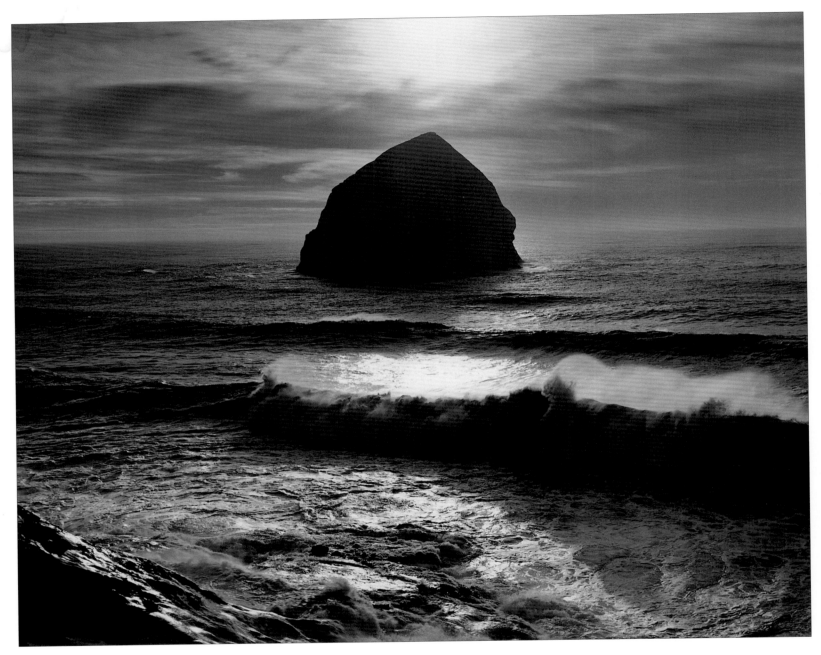

Haystack Rock
Circa 1950. Pacific City's Haystack
Rock has stood sentinel in the surf for
centuries. Several geologic formations
on Oregon's coast share this name;
another one that Ray photographed
hundreds of times punctuates the surf
at Cannon Beach. (4" x 5" negative #6283B)